HIGHLIGHTS FROM THE COLLECTION

SELECTED PAINTINGS, SCULPTURE, PHOTOGRAPHS & DECORATIVE ART

HIGH MUSEUM OF ART, ATLANTA

Photography for this book was coordinated by Jody Cohen, associate registrar. Contributors to the texts include Judy Larson, curator of American art; Cynthia Payne, curatorial assistant, American art; Donald Peirce, curator of decorative art; Linda Boyte, curatorial assistant, decorative art; Niria Leyva-Gutierrez, curatorial assistant, European art; Susan Krane, curator of modern & contemporary art; Carrie Przybilla, associate curator of modern & contemporary art; Ellen Dugan, curator of photography; and Anna Bloomfield, curatorial assistant, photography. Additional assistant was given by Marjorie Harvey, manager of exhibitions; Susan Feagan, assistant to the manager of exhibitions; Frances Francis, registrar; and Terry Greenfield, assistant registrar.

Published by the High Museum of Art
Atlanta, Georgia

Edited by Kelly Morris,
assisted by Amanda Woods

Designed by Jim Zambounis, Atlanta
Type set by Katherine Gunn, Williams
Printing, Atlanta
Printed by Balding + Mansell,
Peterborough, England

Library of Congress No. 94-72752
ISBN 0-939802-77-5 (hardbound)

Library of Congress No. 94-72752
ISBN 0-939802-78-3 (softbound)

FOREWORD

The collection of an art museum is its most essential aspect–it constitutes the fingerprint of the institution. Not only does the collection comprise the museum's identity, but if the artists represented succeed in provoking, challenging, and inspiring viewers through their uncanny talents and the qualities of their works, then we can truly say that the works of art deliver the "touch" of the museum. The collection defines both the scope and the depth of experiences available to the museum's visitors.

And with a permanent collection, as opposed to the ever-changing roster of temporary exhibitions, one can develop a rapport with certain objects over a period of time. This means that you can visit, revisit, and continue to know and see over the years works of art that you hold special. This was an important experience for me as a young person–to see the same work apparently change each time I would return to it. As I matured, I of course realized that it was not the painting that was different, but rather it was I and how I was looking at the work that had shifted. I gradually realized that such transformations often occur in our vision of artworks or people or places. We understand and, at times, measure our growth through our changing experience of the same things.

Our enjoyment of the works of art reproduced in this volume is made

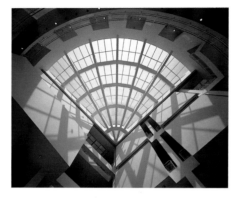

possible by many people's efforts. The Museum is a place where we all celebrate the visions of the artists who create such objects. But it is also necessary for someone to purchase the object, care for it, nurture it, protect it from the hazards of the world, and think about it, research it, and keep it alive in so many ways. Finally the work must be presented in a context that makes it vibrant and relevant to those who come to see it. This volume is dedicated to the numerous artists, donors, patrons, members, volunteers, art handlers, registrars, curators, conservators, and directors whose efforts have ensured that our collections will continue to prosper.

While even the finest photographs can only begin to convey the power, magic, and beauty of these objects, we hope that the publication of these highlights from our collections will inspire you to view the works of art themselves and experience their

effect directly. The fingerprint is, after all, no one individual's mark in this instance. It is the yield of years of individuals who understood the value and meaning of providing a visual legacy for the future, so that generations to come could know something we deemed important and worthy of standing before and viewing. It is our hope that you will enjoy this introduction to our collections. Please regard it as an invitation to discover the wonder and excitement of the works of art in our Museum.

Ned Rifkin, Director

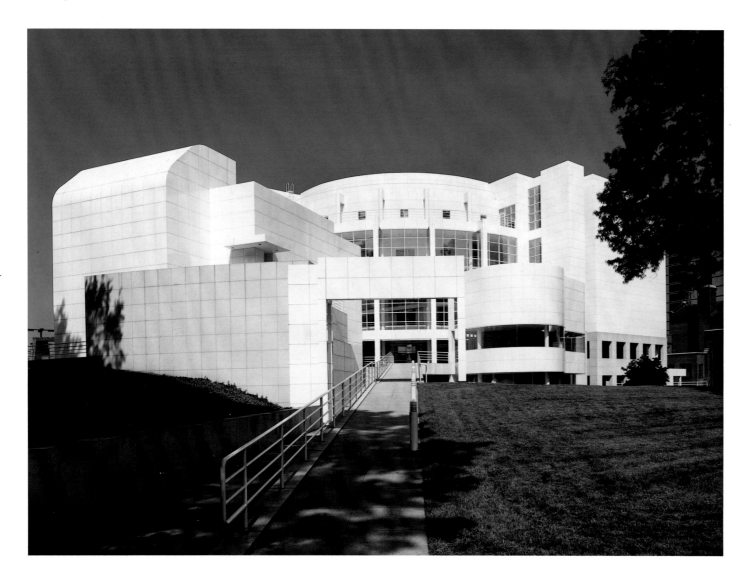

4

THE BUILDING

The High Museum of Art's first home was a family residence on Peachtree Street donated by Mrs. Joseph M. High in 1926. The Museum entered a period of significant growth in 1955, when it moved into a new brick building adjacent to the old High house. In June 1962, 114 Georgia art patrons on a Museum-sponsored European tour were killed in a plane crash near Paris. The Atlanta Arts Alliance was founded in their memory, and in their honor the Memorial Arts Building, which opened in 1968, was constructed over and around the existing Museum. The Museum's usable space was not greatly increased, however, and once enclosed the Museum had little room for expansion.

The High's 1974 long-range plan concluded that the Museum–which could display only 20% of its permanent collection and could not accommodate large traveling exhibitions–desperately needed to expand. Five years later, hints of a major grant from the Atlanta philanthropist Robert W. Woodruff inspired rapid action: nine months of intense planning, research, architectural feasibility studies, and preparations for fund-raising. In December 1979, a $7.5 million challenge grant from Robert W. Woodruff was announced.

In June 1980, the Museum's board of directors approved the selection

of Richard Meier and Associates of New York to design the new building. Meier, hailed as "a supremely gifted shaper of architectural form, an inventor," was the unanimous choice of the search committee. In October, Beers Construction Company was chosen as general contractor.

Meier released the drawings for the building in April 1981, writing, "The building is designed to welcome the visitor, to arouse interest and curiosity and yet convey its sense of purpose as a contemplative place. It is a many-faceted structure, not intended to awe or overwhelm. It presents a variety of spaces, scales, and views, while maintaining a clear relationship of the architectural parts, so that the visitor retains his orientation." Groundbreaking took place in July 1981.

The Museum is constructed of concrete slabs and steel columns and frame. Once the foundations and skeletal structure were in place, the building was prepared for the application of Meier's trademark white porcelain-enameled steel panels. The base of the building was enclosed by granite panels of the same size and shape. A gridded window system completed the building's skin.

The new High Museum of Art officially opened to the public on October 15, 1983. Set well back from Peachtree Street, the building is entered through a piano-curved recep-

tion pavilion, from which one passes into the four-story, quarter-circle glazed atrium. The interior ramp system and the solid atrium walls mediate between the light-filled central space and the art itself, which may be seen and reseen from various levels, angles, and distances. Spatial variety is created in the galleries by natural light, framed vistas, multiple scales, and glimpses into other galleries, the atrium, and the outside.

The High Museum's new building attracted international attention and many honors. The Museum received the American Institute of Architects 1984 Honor Award, the Distinguished Architecture Award from the New York Chapter of the American Institute of Architects, the Bronze Medal Award from the Georgia AIA chapter, the Award of Excellence from the Atlanta Urban Design Commission, and the Georgia Association of Museums Award. Richard Meier was awarded the 1984 Pritzker Prize, the most coveted international architecture honor.

THE COLLECTIONS

The permanent collection received its first major donation in 1949, with the bequest of the Atlanta collector J. J. Haverty, which included works by Chase, Tanner, Twachtman, and Hassam. The Ralph K. Uhry Print Collection was founded in 1955. In 1958, the bequest of Edward

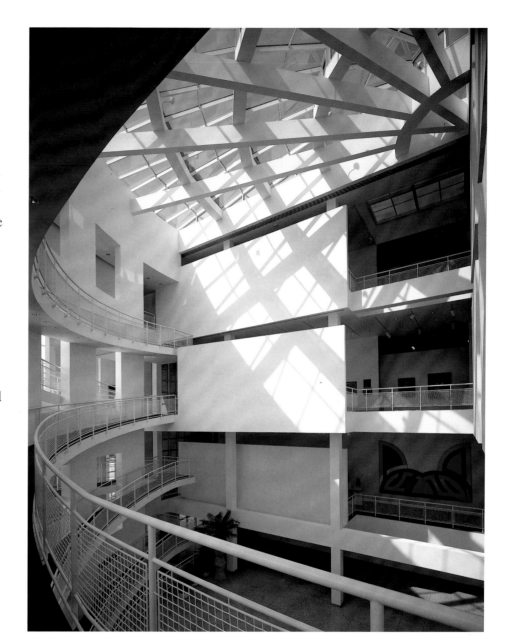

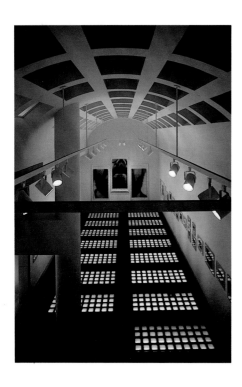

McBurney expanded the Museum's interests in decorative arts, and the Samuel H. Kress Foundation enriched the collection of European art with a gift of twenty-seven Italian paintings and three pieces of sculpture from the fourteenth through the eighteenth centuries.

Since 1972, gifts from Fred and Rita Richman have made the High Museum a regional center for African art and artifacts. Gallery space has been devoted to this collection since 1977.

Enhanced by the long-term loan of the West Collection, the Museum's American paintings, especially nineteenth-century landscapes, continue to be an important feature of its displays.

The High's decorative arts collection has attained national significance with the continuing expansion of the Frances and Emory Cocke Collection of English Ceramics and the 1983 unveiling of the extraordinary Virginia Carroll Crawford Collection of American Decorative Arts, 1825-1917. Broad community interest in the decorative arts has added to the collection through the Decorative Arts Acquisition Trust, a project of the Friends of the Decorative Arts.

The acquisition of folk art has become a major area of interest for the Museum in this decade, leading to the addition of the Nasisse collection and the appointment of a curator in this area.

The collection of contemporary art has grown dramatically in recent years, with support from the National Endowment for the Arts, the Twentieth Century Art Society, and local collectors. The collection focuses on works from the 1970s on and reflects the Museum's commitment to diversity and artistic breadth.

The photography collection has grown steadily since its inception in 1974. It now numbers more than 3,500 images and since 1993 has been under the care of a fulltime curator. The Lucinda Bunnen Collection, established in 1983, continues to add new photographs to the Museum's holdings.

THE DOWNTOWN BRANCH

The High Museum branch at Georgia-Pacific Center in the downtown business district opened to the public in February of 1986. The Center's co-owners, the Georgia-Pacific Corporation and the Metropolitan Life Insurance Company, contributed the new facility, designed by Parker and Scogin Architects, Inc., and built by Winter Construction Company. The branch's 4,500 square feet of gallery space were at first used to display the Museum's permanent collection and traveling exhibitions of all kinds. In 1993, the facility was rededicated as the High Museum of Art Folk Art and Photography Galleries.

HIGHLIGHTS FROM THE COLLECTION

Within categories of African Art, American Art, Decorative Art, European Art, Folk Art, Modern & Contemporary Art, and Photography, works are in loose chronological order. Dimensions are given height before width before depth.

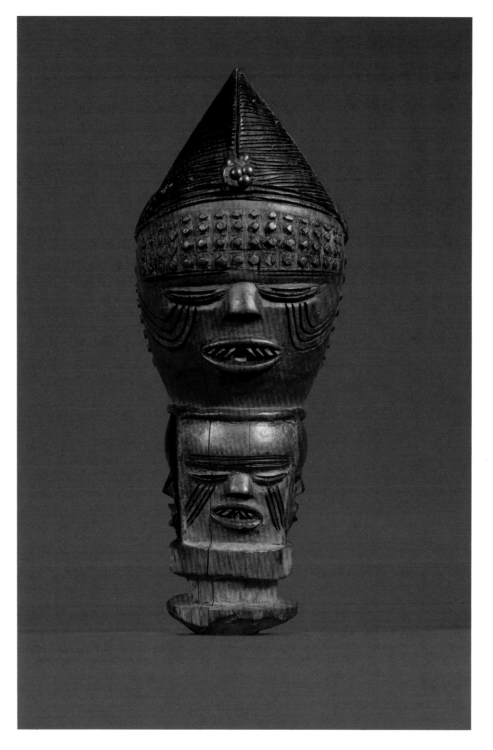

Dance Baton
Kuyu, Republic of the Congo, wood, pigment, and brass, 15 inches high, Fred and Rita Richman Collection, 1984.327

The Kuyu of the Congo and western Zaire produce elaborately carved and painted wooden dance batons called *Kebe-Kebe* used in initiation ceremonies. The characteristic ridged coiffure projects to a point and is accented with brass tacks. Most Kuyu batons have distinctive scarification patterns of incised lines and raised dots, primarily on the forehead, under the eyes, and on the cheeks. The eyes are narrow and the ears small. The open mouth reveals individually carved pointed teeth. The neck of the staff may be covered with carved human faces or geometrical patterns.

Standing Figure
Baga, Guinea, wood, 25 inches high, gift of
Helena Rubinstein, 53.12

The social and religious life of the Baga
is governed by the Simo society, which
supervises the initiation rites of young
men, the funeral ceremonies of elders,
and the carving of several types of masks,
figures, and shrine objects. Protective
wooden figures such as this one were
placed in male and female pairs in shrines
located between the village and the bush
to ensure agricultural and human fertility.
The enlarged head with aquiline nose,
elaborate coiffure, and complex facial scar-
ification is in the style of Baga shoulder or
yoke masks worn during fertility festivals.

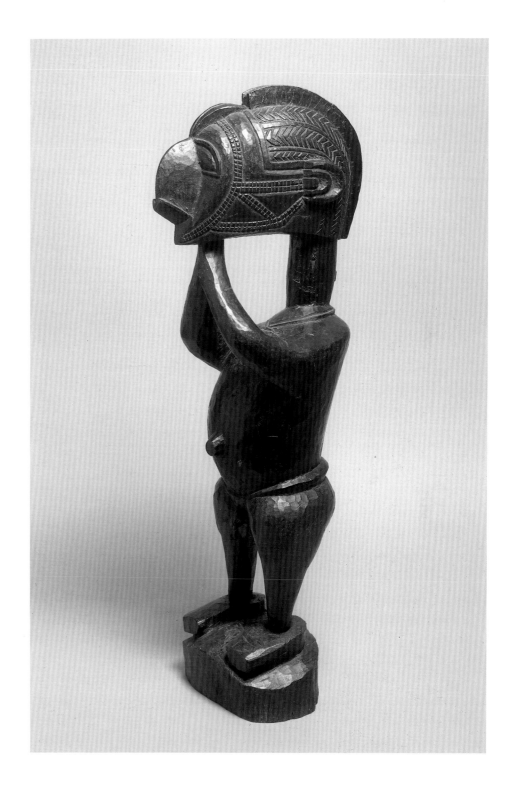

9

RALPH EARL
American, 1751-1801

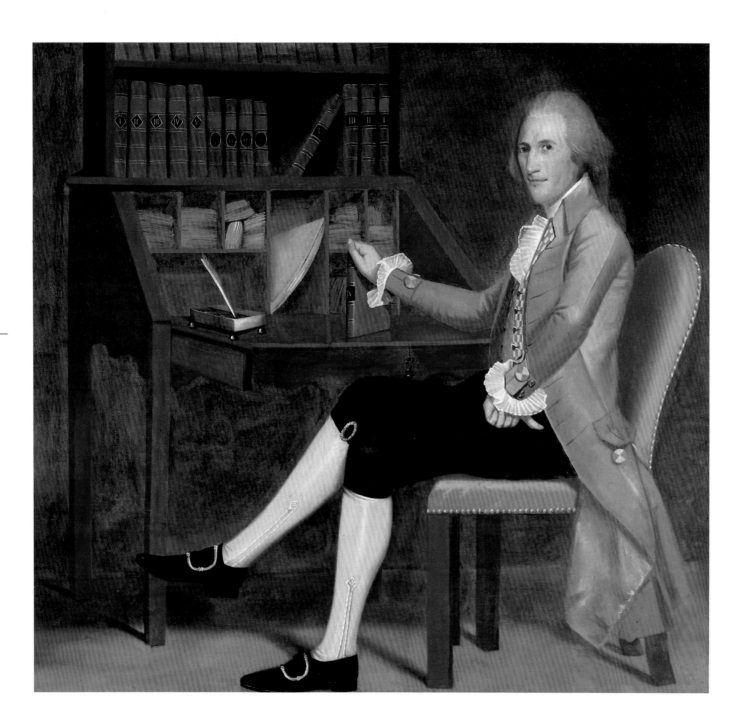

Portrait of David Baldwin, 1790
Oil on canvas, 56³/₄ x 61⁷/₈ inches, purchase in honor of Lawrence L. Gellerstedt, Jr., President of the Board of Directors, 1984-86, with funds from Alfred Austell Thornton in memory of Leila Austell Thornton and Albert Edward Thornton, Sr., and Sarah Miller Venable and William Hoyt Venable, 1985.221

Ralph Earl was among the better trained of the many artists who painted portraits for prominent families of the new American republic. Though he was not skilled at creating illusionistic effects, he succeeded in producing dignified likenesses of his sitters.

Earl worked primarily in the Connecticut River Valley, traveling from town to town in pursuit of commissions. In 1790 he painted at least seventeen portraits in the Litchfield, New Milford, and Newtown, Connecticut, areas, including that of David Baldwin, a prominent Newtown merchant. Confidently engaging the viewer's eye, Baldwin is portrayed as a gentleman of means, clad in his finest attire and surrounded by his possessions.

HENRY INMAN
American, 1801-1846

Yoholo-Micco, 1832-33

Oil on canvas, 30³/₈ x 25⁷/₁₆ inches, anonymous gift, 1984.176

Thomas L. McKenney, United States superintendent of Indian trade from 1816 to 1824 and head of the Bureau of Indian Affairs from 1824 to 1830, commissioned Charles Bird King, the most sought-after portraitist in Washington, D.C., to paint portraits of the chiefs and warriors who visited the capital to negotiate treaties and resettlement terms with the federal government. By 1830 King had finished more than 100 paintings on panels measuring eighteen by fourteen inches. McKenney decided to publish a portfolio of lithographs based on the paintings, and the United States agreed to lend the portraits to him for a short time after he lost his position and moved to Philadelphia.

In 1831 McKenney commissioned Henry Inman, a well-established portraitist, to make oil copies of King's originals from which his lithographers could work. Inman enlarged the figures to life size in his nearly 120 copies, but made no other changes. In 1865 a fire at the Smithsonian Institution destroyed nearly all of King's originals, leaving Inman's copies the chief visual record of the great American Indian leaders of the early nineteenth century.

Yoholo-Micco headed the Creek delegation which went to Washington in November 1825 to protest a fraudulent treaty requiring his nation to cede most of its remaining southeastern territory and move west. The Creeks were able to negotiate a more favorable treaty and win back some of their lands. "Micco" means king or chief, and "Yoholo" signifies one of royal blood.

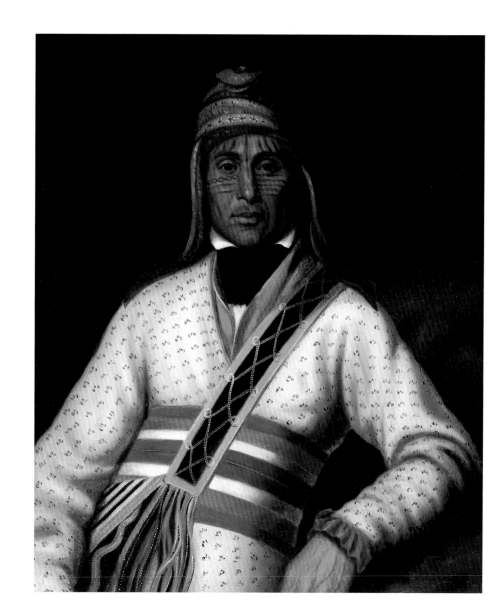

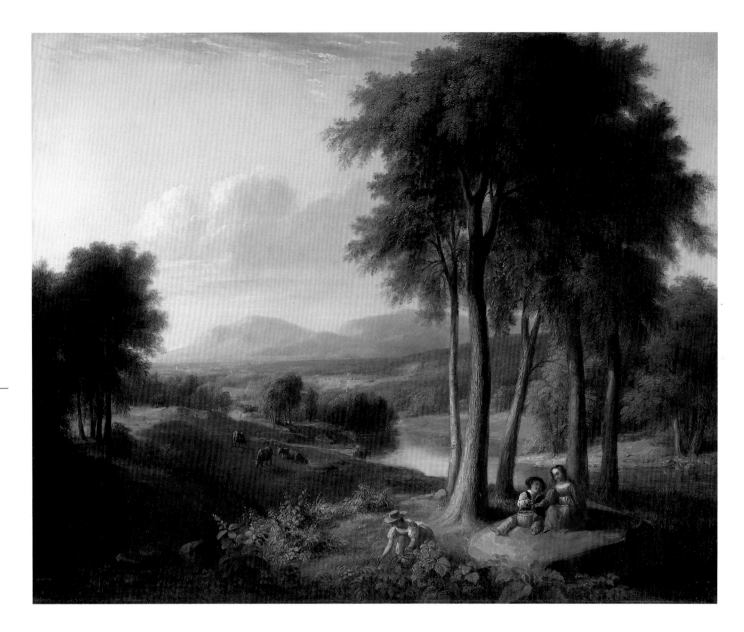

ASHER B. DURAND
American, 1796-1886

*View near Rutland, Vermont
(Landscape with Children)*, 1837
Oil on canvas, 29¼ x 36¼ inches, purchase
with funds from Mrs. J. Mack Robinson,
1993.100

Asher B. Durand was recognized in his
lifetime as one of the fathers of American
landscape painting. In the mid-1830s,
Durand forsook engraving for painting.
After several portrait commissions, the
artist began painting landscapes at the
urging of his friend Thomas Cole, who
advised him to explore the countryside
for his physical and mental well-being.
Durand accompanied Cole on a painting
expedition in the Adirondacks in 1837.

View near Rutland, Vermont evidences
Durand's awakening interest in American
scenery. Its style is detailed and precise,
reflecting the artist's experience as an
engraver. In this painting, a specifically
American scene is an emblem of nature's
bounty, a new Eden, foreshadowing in
subject and meaning later developments
in nineteenth-century American land-
scape painting.

JOHN FREDERICK KENSETT
American, 1816-1872

Camel's Hump from the Western Shore of Lake Champlain, 1852
Oil on canvas, 31³/₈ x 45³/₁₆ inches, gift of Virginia Carroll Crawford, 76.67

John F. Kensett turned to painting as a release from the tedium of his work as an engraver. In 1840 he joined John W. Casilear and Asher B. Durand on the first of many journeys he would make to Europe. He remained unswayed by such European trends as the Barbizon School of landscape painting, however, and steadfastly adhered to the native American luminist-realist tradition.

A prominent member of the Hudson River School, Kensett was profoundly moved by the landscape of New York and New England. In *Camel's Hump*, he painted the Green Mountains of Vermont as seen from the New York shore of Lake Champlain, where he sketched in the summer of 1848. This was a vista acclaimed by popular nineteenth-century guidebooks, one which contemporary nature-lovers would easily have recognized. The artist realistically depicted this rural American scene, framing his composition in a manner that reflects his study of the works of the seventeenth-century French landscapist Claude Lorrain. The use of suffused light and delicate color recalls Kensett's observation that "bright colors are sparingly distributed throughout the natural world . . . the main masses are made up of cool greens, grays, drabs and browns intermingled."

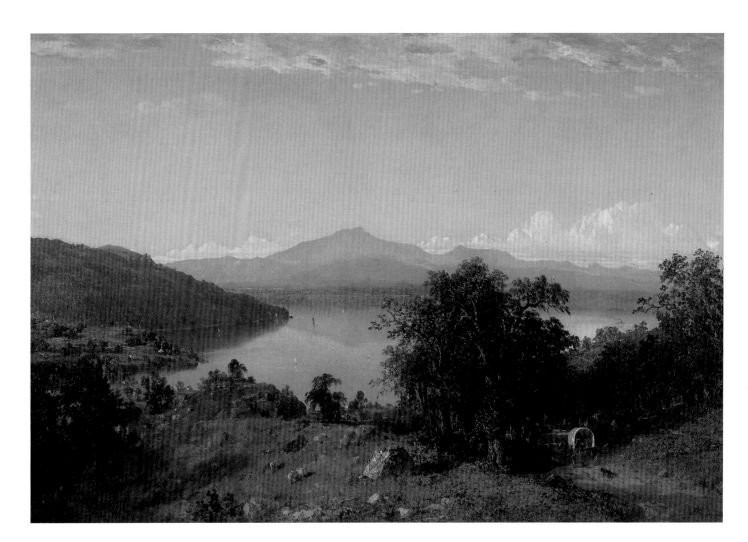

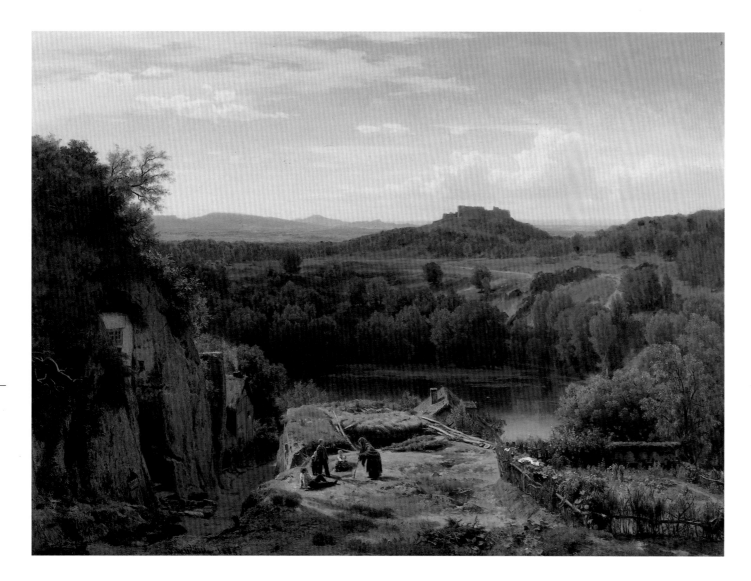

THOMAS WORTHINGTON
WHITTREDGE
American, 1820-1910

*Landscape in the Harz
Mountains*, ca. 1852
Oil on canvas, 46⅝ x 63⅜ inches, gift in
memory of Howard R. Peevy from his wife,
73.50

Like many American artists of his genera-
tion, Worthington Whittredge recognized
the limitations of his native environment
and believed his career would be enhanced
by study abroad. In 1849 he journeyed to
Europe, where he sought instruction from
the principal landscape painters of the
Düsseldorf Academy.

Landscape in the Harz Mountains
attests to the sophistication of style
Whittredge acquired in Düsseldorf, par-
ticularly as a result of study with Carl
Friedrich Lessing. The artist's introduction
of a small scene of rustic life and his sen-
sitivity to atmospheric effects enrich his
finished composition, imbuing it with
sentiment and romance.

ALBERT BIERSTADT
American, 1830-1902

Pioneers of the Woods, ca. 1863-73
Oil on paper, mounted to canvas, 19 x 25^{15}/$_{16}$ inches, gift of the Exposition Foundation, 71.27

This oil sketch of two towering, weather-beaten oaks is one of many detailed preparatory studies Albert Bierstadt made for the stunning monumental landscapes he produced as a result of his participation in several survey expeditions to the American West. The work was probably painted during his 1863 visit to California, Oregon, and Washington or his 1871-73 visit to central California. Stylistically, the study (which has not been clearly associated with any of Bierstadt's finished paintings) differs in its simplicity and emphasis on detail from the elaborately composed views he produced in his New York studio. Its realism and sense of immediacy bespeak the artist's presence before his subject.

The young Bierstadt had studied art at the Academy in Düsseldorf, Germany, and much of his early work demonstrates the painterly approach he developed there to create the illusion of deep space. The relatively shallow space depicted in *Pioneers of the Woods* and the bright coloration which emphasizes the picture's surface support the assignment of this painting to the artist's mature years.

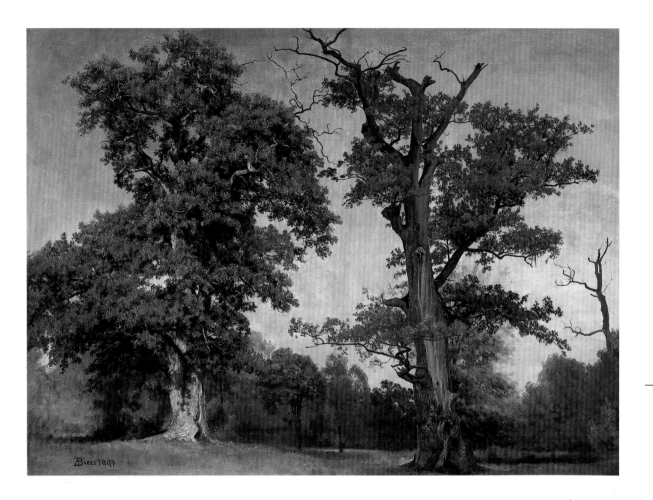

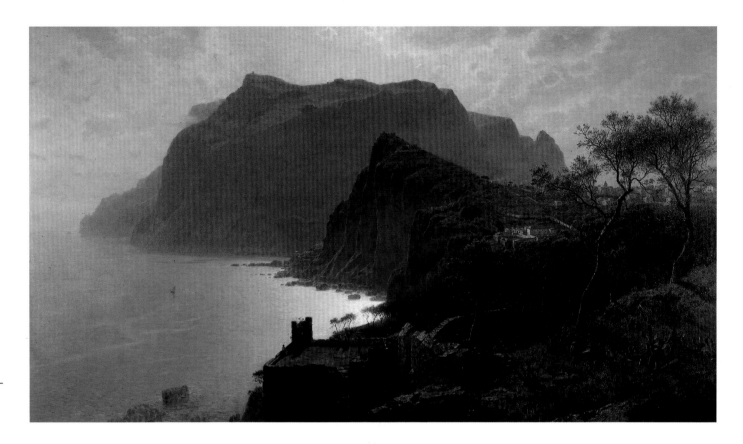

WILLIAM STANLEY HASELTINE
American, 1835-1900

The Sea from Capri, 1875

Oil on canvas, 41¼ x 72⅞ inches, purchase with funds from the Members Guild in honor of Mrs. Wilbur Warner, President of the Members Guild, 1982-83, 1982.321

Like many American artists in the late nineteenth century, William Stanley Haseltine became known for his Italian views. He first visited Capri, a small island in the Bay of Naples, in 1858, staying in the Carthusian Monastery of Saint John that appears atop the precipitous limestone cliff in *The Sea from Capri*. In the painting's foreground are the ruins of the Villa Jovis, built by the Emperor Tiberius in the first century.

Haseltine developed his meticulous drawing style as a student of the German artist Paul Weber in Pennsylvania and through study at the Düsseldorf Academy. He read the works of John Ruskin, who urged that fidelity to nature be the criterion for art, and admired the clarity and planar structure of the luminist paintings of Sanford Gifford and William Bradford. In the 1860s he studied the optical effects created by the French Barbizon artists, but he did not abandon his commitment to realism in favor of the Barbizon penchant for suppressing detail. *The Sea from Capri* demonstrates the Barbizon influence on Haseltine, who no longer used light and shade merely to model objects, but instead made the light that is reflected from the distant cliffs and that shimmers over the water, shrubs, and grasses the subject of his painting.

MARTIN JOHNSON HEADE
American, 1819-1904

Two Hummingbirds with an Orchid, 1875

Oil on canvas, 17⁹/₁₆ x 27¹/₂ inches, purchase with David, Helen, and Marian Woodward Fund, 76.3

Martin Johnson Heade had a lifelong passion for hummingbirds and traveled to Brazil in 1863 to paint the many varieties there, envisioning a deluxe publication of chromolithographs–never completed–similar to John James Audubon's engraved *Birds of America*. The artist added orchids to his settings after sketching wild species of the plants in Jamaica in 1870. He found models for the flowers in the popular "orchid houses" maintained by wealthy New Yorkers, and many of the hummingbirds he depicted were his own pets. While Heade regularly exhibited his rich, brilliantly lit, iridescent-colored hummingbird and orchid paintings, they were never mentioned in reviews, perhaps because of what was perceived to be their sexual symbolism.

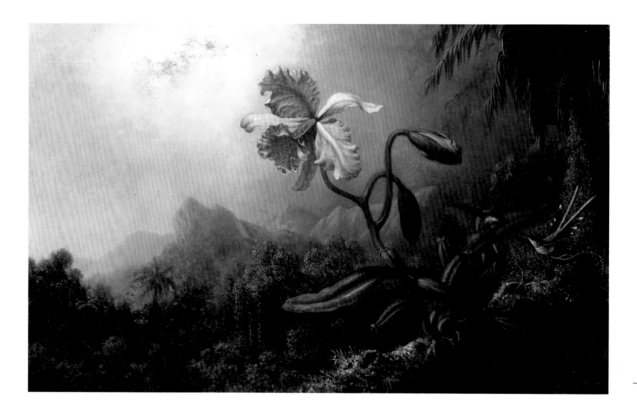

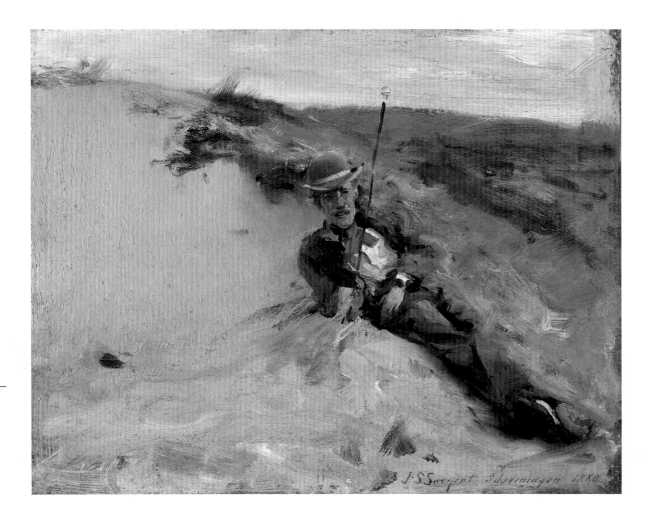

JOHN SINGER SARGENT
American, 1856-1925

Portrait of Ralph Curtis on the Beach at Scheveningen, 1880
Oil on panel, 10½ x 13¹³/₁₆ inches, gift of the Walter Clay Hill and Family Foundation, 73.3

Although in 1880 John Singer Sargent was still nominally a student of the renowned Emile-Auguste Carolus-Duran (1837-1917), he also sought to learn the art and craft of painting from the masters of the past. In the spring of the year he traveled to Haarlem in the Netherlands to copy works by Frans Hals (1581/85-1666). At the time he executed this portrait of his cousin Ralph Curtis (1854-1922), his companion on the trip, Sargent was engaged in faithfully copying a group of spirited and brilliantly colorful portraits by Hals. Painted at the beach resort of Scheveningen, near Haarlem, the work reflects the painterly realism, enveloping atmosphere of light and color, and tactile qualities that mark Hals's work. The Curtis portrait demonstrates Sargent's capacity for combining drawing and brushwork in a single action. Its muted color harmonies and deliberate informality, which echo Impressionist sensibilities, foreshadow the characteristics of the many casual portraits of close friends Sargent would paint in the years ahead.

RALPH ALBERT BLAKELOCK
American, 1847-1919

Moonlight, ca. 1883-89
Oil on canvas, 30 x 25 inches, purchase with
funds from the Friends of Art, 38.4

Ralph Blakelock was essentially a self-
taught artist who painted in response to
a personal vision, seeking to express the
spirituality and mystery of nature. Like
a composer working out variations on a
theme, he obsessively rendered moonlight
scenes, capturing the many nuances of
lunar light. In this painting, the icy jade
green sky is relieved by the creamy yellow-
white glow of the moon, which picks out
the lacy silhouette of the tree to the right.
The atmosphere is haunting, and a subtle
balance is struck between the manifest
and the imagined.

Blakelock's visionary paintings were so
unconventional that he was rarely able to
sell them. Pressured by the needs of his
large family, he often painted in haste,
hoping to market his works by the lot. He
suffered a mental breakdown in the early
1890s and was eventually institution-
alized. Ironically, his collapse finally
brought his work to the attention of
collectors and dealers.

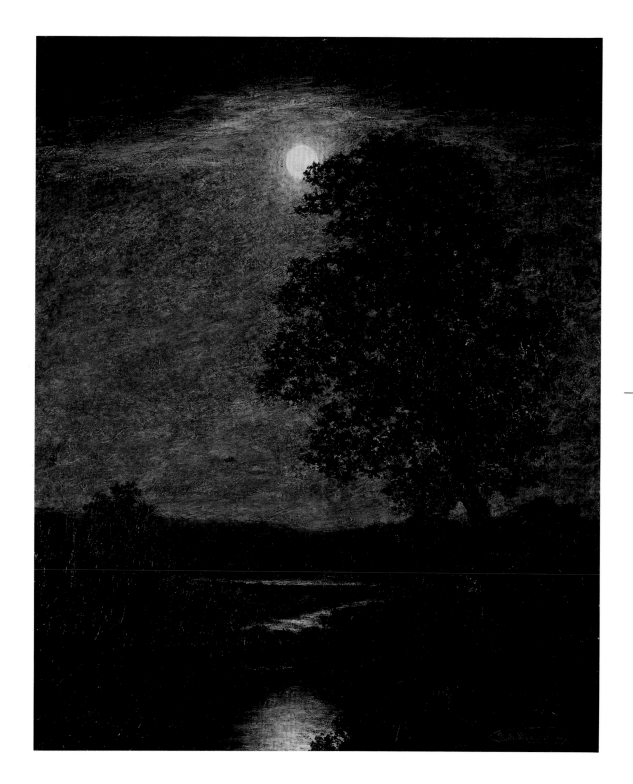

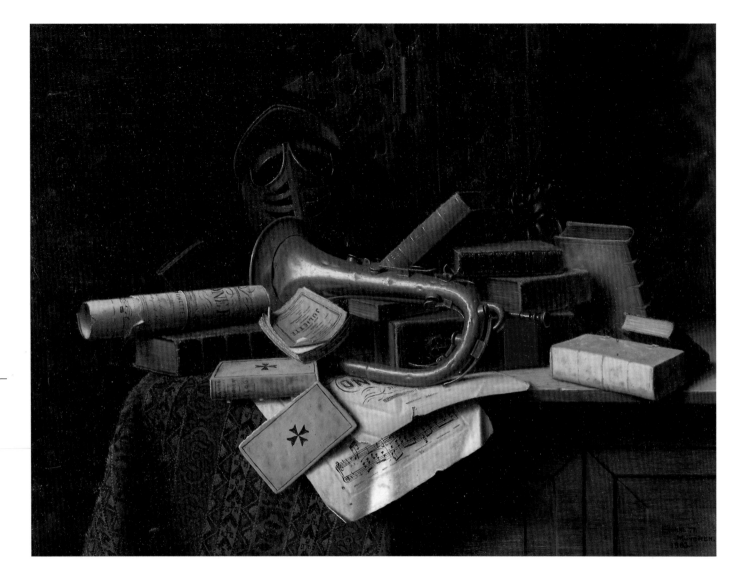

WILLIAM MICHAEL HARNETT
American, 1848-1892

Still Life with Bust of Dante, 1883
Oil on panel, 10⁵/₁₆ x 13¹³/₁₆ inches, gift of
Mr. and Mrs. James M. Dyer and Mr. and
Mrs. Truman Bragg in memory of Mrs. Mary
Newcomb Bull and Robert Scott Newcomb,
64.27

Trompe l'oeil or "fool-the-eye" still-life
painting sparked great enthusiasm among
collectors in the late nineteenth century.
In *Still Life with Bust of Dante*, William
M. Harnett, the best known of the illu-
sionistic "deceivers," combined pristine
brushwork with a complex but carefully
balanced composition and interwove
literary references with many of his
favorite props.

The captivating visual effects in
Harnett's paintings sometimes draw atten-
tion from the themes and ideas suggested
by the objects depicted. The armorial hel-
met in this still life evokes the concepts
of courage and action as embodied by the
medieval knight. The books may repre-
sent the wise and contemplative scholar.
Vanitas elements—symbols of the futility
of human endeavor—include a tattered
copy of Dante's *Divine Comedy*, a work
of the late medieval period which empha-
sizes the transience of worldly things
and the certainty of Christian salvation.
Harnett made many references to the
Middle Ages in his art, but he left little
in writing that might help explain them.

ALFRED CORNELIUS HOWLAND
American, 1838-1909

Fourth of July Parade, ca. 1886

Oil on canvas, 24 x 36¹/₁₆ inches, gift of Life Insurance Company of Georgia in celebration of the Nation's Bicentennial, 75.51

Alfred Cornelius Howland was a respected member of the New York artistic community–a regular contributor to National Academy of Design exhibitions and a member of the renowned Century Association. The city, however, did not interest him as a subject. It was his boyhood home of Walpole, New Hampshire, that claimed his affection, and the village celebration of the Fourth of July was "the Idolized day of [his] Boyish Fancy."

Howland's recollections of the town and its citizens are seen in at least two versions of *Fourth of July Parade*; this painting is assumed to be a large preparatory study for a larger canvas exhibited in 1893 at the World's Columbian Exposition in Chicago. The anecdotal humor, taste for genre, and precision of detail in the work reflect the artist's training at the Düsseldorf Academy, and his painterly concern with light and atmosphere suggests an interest in the landscapes of the French Barbizon School.

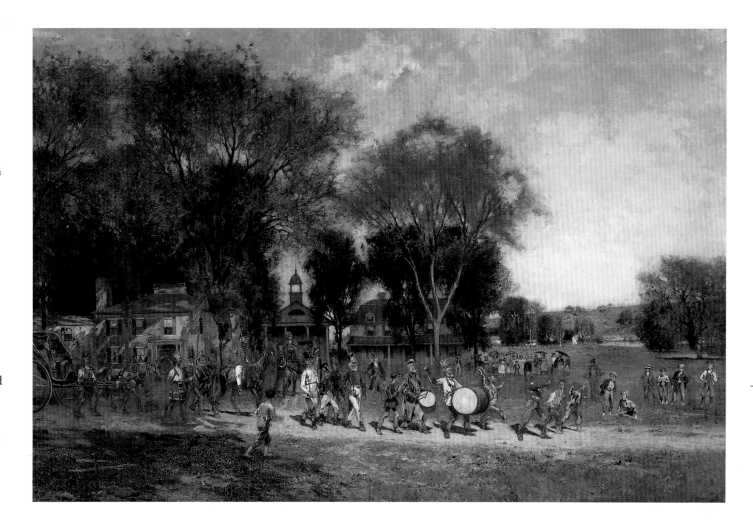

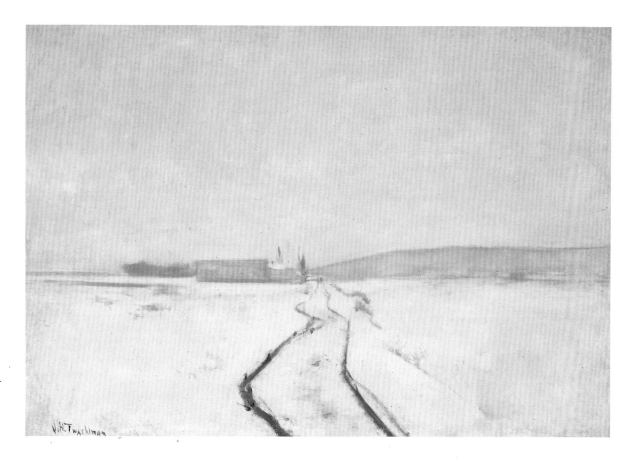

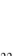

JOHN HENRY TWACHTMAN
American, 1853-1902

Along the River, Winter, ca. 1889
Oil on canvas, 15⅛ x 21¹¹/₁₆ inches,
J. J. Haverty Collection, 49.28

In 1880 John H. Twachtman visited
Venice, where he met the painter and
printmaker James A. McN. Whistler
(1834-1904). Perhaps influenced by this
contact, Twachtman began to turn away
from the somber tonalities his work had
acquired as a result of study at the Royal
Academy of Fine Arts in Munich toward
a more lyrical colorism. Within the next
few years, during which Twachtman
sought further instruction in Paris, his
work began to exhibit Impressionist ten-
dencies, with an emphasis on the sim-
plification of form and a preference for
cool gray and green harmonies. Detail is
eliminated in favor of an atmospheric ren-
dering of nature that emphasizes a mood
of poetic reverie and quiet contemplation.

By 1889 Twachtman had purchased a
farm near Greenwich, Connecticut. *Along
the River, Winter* is thought to be a work
from this final period of the artist's career.
Nothing specific in the painting connects
it with Connecticut scenery, but, espe-
cially in the snowy quiet of winter, the
landscape around his farm offered the
artist unparalleled opportunities for refin-
ing and perfecting his concept of painting
as tonal poetry.

GEORGE INNESS
American, 1825-1894

The Passing Storm, 1892
Oil on canvas, 30⅛ x 45¹/₁₆ inches, gift of
Mrs. Howard R. Peevy, 75.53

In the final decade of his career, George
Inness evolved a highly original and per-
sonal style of painting that reflects his
early attachment to Claudean and Bar-
bizon influences. Along with other artists
who are today referred to as tonalists, he
deliberately pursued a path antithetical to
Impressionism, creating works imbued
with a mood of poetic elegy and quietism.
In tonalist painting, the eye is not seduced
by vibrating color notes; rather, it is
brought into a dreamlike confrontation
with nature, seen as if through a diaph-
anous veil of hazy air.

A marked spirituality also pervades
Inness's late paintings. As a convert to
Swedenborgianism, the artist believed in
the inescapable unity of religion and land-
scape (the invisible and visible duality
of the world) with human nature. *The
Passing Storm*, like his other treatments
of the storm theme, is as much a meta-
phor of the human spirit's deliverance
from turmoil as it is the record of a
visual experience.

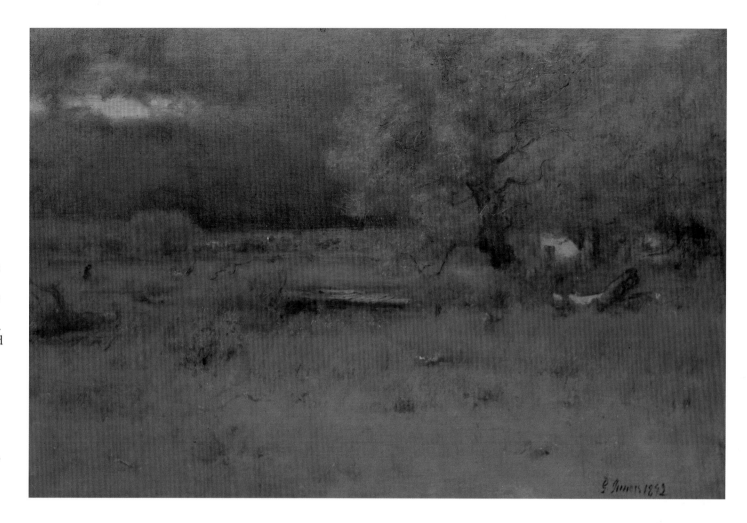

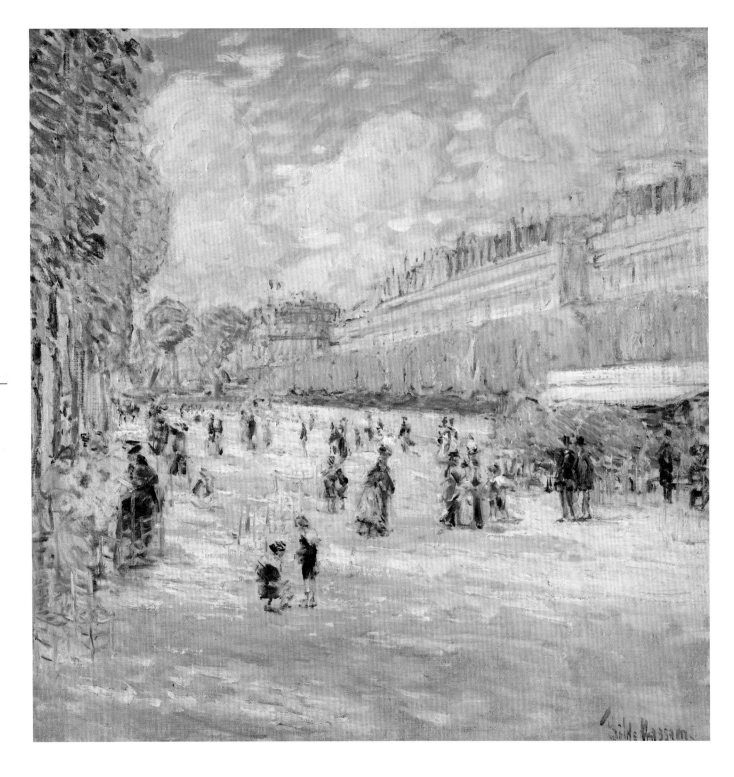

CHILDE HASSAM
American, 1859-1935

Tuileries Gardens, ca. 1897
Oil on canvas, 24¹/₁₆ x 24¹/₈ inches, gift of
Miss Mary E. Haverty for the J. J. Haverty
Collection, 61.66

By the time Childe Hassam painted
Tuileries Gardens, Impressionism had
become an accepted and admired mode
of artistic expression in the United States,
embraced alike by art establishment arbi-
ters, such as the National Academy of
Design, and prominent collectors. A prod-
uct of the artist's third trip to Europe, this
Parisian scene is one of a series of pictures
in which he experimented with the high-
est register of pale, yet colorful, chromatic
harmonies. The putative subject of
Tuileries Gardens is, in fact, merely a pre-
text for Hassam's inventive use of color,
marking the artist as a true exponent of
Impressionism.

GEORGE BENJAMIN LUKS
American, 1867-1933

Winter–High Bridge Park, 1912-13
Oil on canvas, 22 x 34 inches, purchase with
Henry B. Scott Fund and funds from the
Friends of Art, 36.8

During the 1890s, while working as an
artist-correspondent for various Phila-
delphia newspapers, George Luks devel-
oped a rapid drawing style and a sharp eye
for the details that could economically
convey character and action. After mov-
ing to New York, he began to concentrate
on the realistic depiction of urban life, fre-
quently portraying its seamier side with
brutal honesty. His choice of subject mat-
ter disturbed many, but others credited
him with the creation of a new American
idiom. He and Robert Henri, William
Glackens, Everett Shinn, and John Sloan,
all former Philadelphia artists and illustra-
tors, eventually formed the core of the
New York-based Ashcan School.

Luks frequently chose High Bridge Park,
near his home in upper Manhattan, as a
subject. In this work, his quick, economi-
cal method of applying paint captures the
spontaneity of children at play. Using dabs
of pink for the children's faces and parallel
strokes of color for their stockings, Luks
draws the viewer's attention away from
the specific and focuses it instead on the
spirited action of the whole scene. The
tiny patches of colorful paint that fill the
background enhance the vibrant energy of
the canvas.

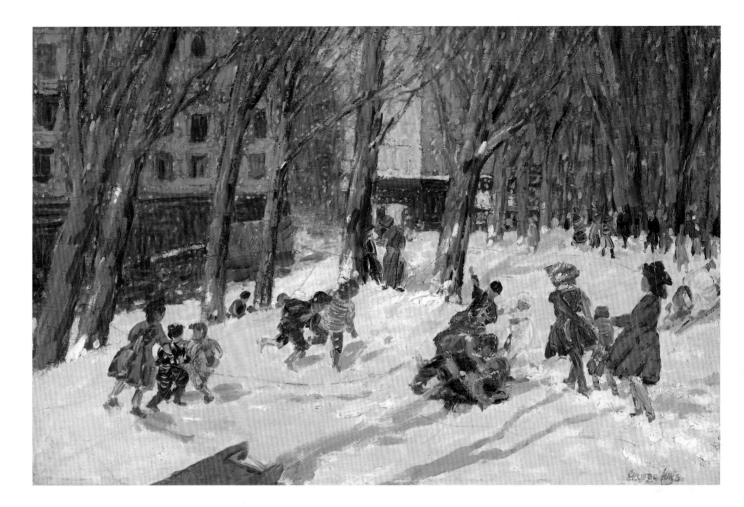

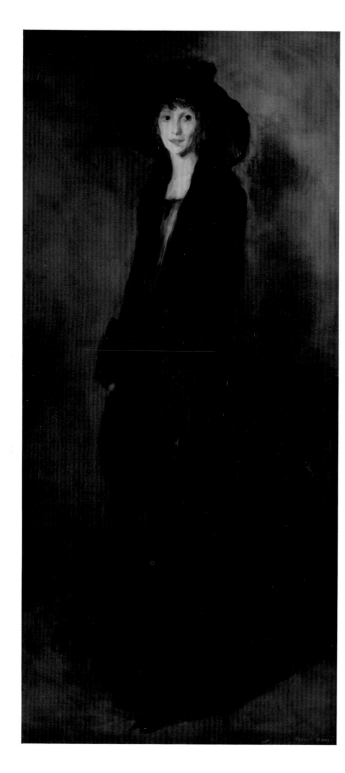

ROBERT HENRI
American, 1865-1929

Lady in Black Velvet (Eulabee Dix Becker), 1911

Oil on canvas, 77¹/₈ x 36¹⁵/₁₆ inches, gift in memory of Dr. Thomas P. Hinman through exchange and general funds, 73.55

Robert Henri was the leader of the Eight, an early twentieth-century group of American realist artists united not by stylistic characteristics or choice of subject matter but by an attitude that valued individual expression. Painted at the height of Henri's career, *Lady in Black Velvet* is one of several portraits he did between 1904 and 1911 in which female models are dressed completely in black or white.

 Henri met the miniature painter Eulabee Dix through a group of artists and writers who gathered in New York around the Irish painter and philosopher John Butler Yeats. He portrayed Dix as a self-sufficient, self-confident woman of serious and intelligent mien, using color, gesture, and vigorous brushwork to create not simply a good likeness of his sitter but an expression of her individuality and vitality.

GEORGE BELLOWS
American, 1882-1925

Portrait of Anne, 1915

Oil on canvas, 48⅛ x 36¼ inches, purchase
with Henry B. Scott Fund, 57.27

In 1904 George Bellows went to New York
to study with William Merritt Chase and
Robert Henri at the New York School of
Art. Henri, encouraging his students to
observe life and express their emotions
in paint, particularly influenced Bellows,
whose direct painting style met with
quick success. In 1913 Bellows participated
in the Armory Show, which introduced
the work of European modernists to the
United States. He admired their use of
fresh, pure color and soon began his
own experiments in this vein, developing
the bright, vibrant palette evident in
this portrait.

Anne Bellows was the elder of the
artist's two daughters. By the age of three
she was accustomed to posing for her
father, a task which earned her twenty-
five cents an hour. Her composure and
direct gaze suggest that she was a well-
behaved, self-assured child. Asked once
about her expected teatime guests, she
quickly replied: "God and Rembrandt
and Emma Goldman."

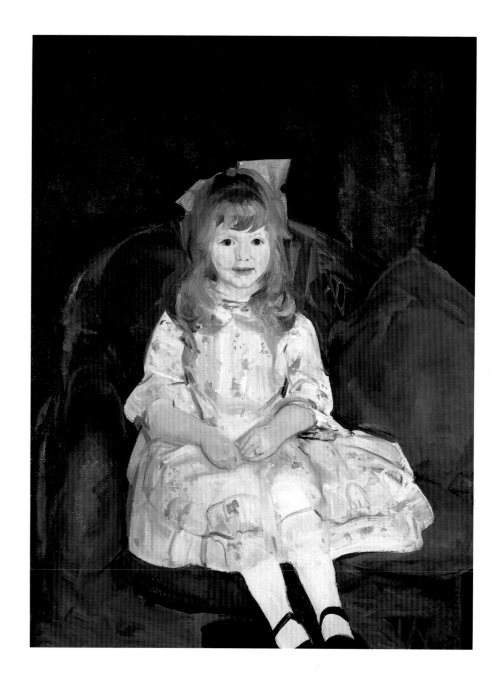

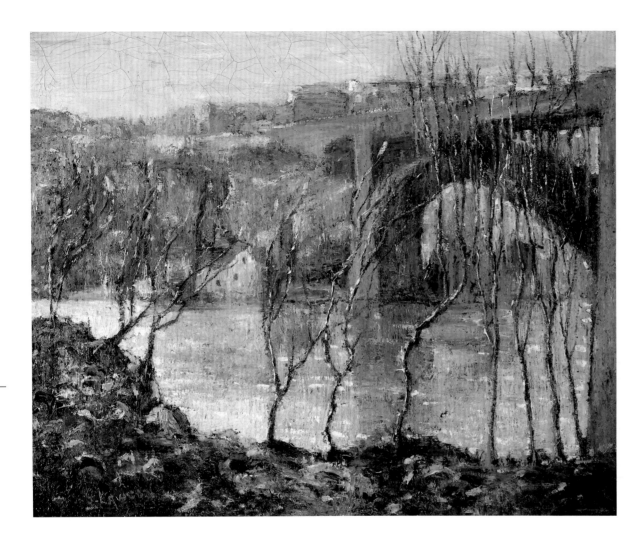

ERNEST LAWSON
American, 1873-1939

Washington Bridge, Harlem River, ca. 1915
Oil on canvas, 20 x 24$\frac{1}{16}$ inches, J. J. Haverty Collection, 49.38

Ernest Lawson was one of the Eight, a group of painters who rejected the rigid criteria imposed by the preeminent American art academies and exhibited together at the Macbeth Gallery in New York in 1908. Though his painting style was rooted in Impressionism, his lifelong interest in the evocative power of color, texture, and form places him firmly in the company of modernist artists. He dedicated himself to depicting the American landscape, especially in winter, including in his views the trestles and girders of bridges, derelict buildings, and barren trees.

Washington Bridge, Harlem River is one of several views Lawson painted near his New York City home in Washington Heights. It reflects his interest in architectonic structure and in the lively patterns created by the bare branches of trees. The buttery quality of the paint softens the hard-edged geometry of the bridge and buildings and adds to the richness of the surface's texture. Lawson expressed emotion chiefly through his use of color, which in this painting fairly vibrates.

HENRY OSSAWA TANNER
American, 1859-1937

Destruction of Sodom and Gomorrah, 1929-30
Tempera and varnish on cardboard, 20³/₈ x 36 inches, J. J. Haverty Collection, 49.32

Henry Ossawa Tanner was one of the few African-Americans who managed to maintain a successful career as an artist in the nineteenth century. He studied at the Pennsylvania Academy of the Fine Arts under Thomas Eakins in the early 1880s and at the Académie Julian in Paris in 1891. Finding it easier to work as a painter in France, the artist thereafter returned to the United States only for visits. He began to exhibit at the annual Paris Salons in 1894 and was eventually made a Chevalier of the French Legion of Honor. Tanner's work was esteemed by American institutions and collectors as well, including the prominent Atlanta collector J. J. Haverty.

Tanner traveled to Palestine several times in the late 1890s and became known as the poet-painter of the Holy Land due to the keen interest he developed in biblical imagery. *Destruction of Sodom and Gomorrah* is one of several versions of the story from Genesis the artist painted. Its abstraction and simplicity of form and color evoke a sense of the interaction of the material and spiritual worlds. The escaping figures of Lot and his two daughters led by the angels are dwarfed by the drama of the conflagration as the cities of Sodom and Gomorrah are destroyed. The thick layering of paint and varnish in greenish blue–a color Tanner deemed the purest, the most beautiful, and the most appropriate for religious themes–creates a surface like glazed porcelain.

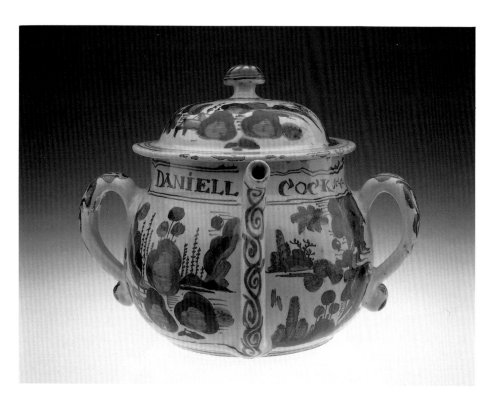

Posset Pot, 1682

Bristol, England, tin-glazed earthenware, 6³/₈ x 10 x 9 inches, gift of the Exposition Company for the Frances and Emory Cocke Collection to mark the retirement of Gudmund Vigtel, 1991.70

Posset (a hot milk drink with ale, wine, or liquor, often prepared with sugar or spices) was consumed at times of convivial celebration, and the pot was passed so that each celebrant could sip through the spout. Inscribed "Daniell Cock" and dated 1682, the Museum's pot undoubtedly commemorated a special event in Cock's life. The posset pot was a completely European (mainly English) table form, replaced in the early eighteenth century by the punch bowl.

Late seventeenth-century English delftware was often decorated in blue, like the Dutch wares it emulated. Motifs were often copied or adapted from Chinese porcelains then being imported into Europe. The hard and white shiny surface of the tin-glazed earthenware was as close as Europeans could come to the coveted high-fired Chinese porcelains of the time.

High Chest, ca. 1725
American, Boston, Massachusetts, walnut, burl walnut, and maple veneers on white pine, 63½ x 41 x 22½ inches, purchase with funds from the Decorative Arts Endowment, 1983.45

Among the most luxurious items in early eighteenth-century New England household inventories were high chests of drawers like this Boston-made example. Its drawers are of sophisticated dove-tailed construction and it was veneered in highly figured walnut and maple, adding considerably to its original cost. The chest represented a transition in New England craft traditions between the general carpenter-joiner and the more specialized cabinetmaker.

The form itself was based on the seventeenth-century English practice of mounting imported Chinese enamel cabinets on locally made stands. The heavy moldings, the six trumpet-shaped turned legs, and the ogee-shaped arch of the skirt (echoed horizontally in the cross-stretchers linking the legs of the base) are New England interpretations of the European Baroque style of the period. This was a showy piece of furniture, and the top may have been used to exhibit imported glass and ceramics and possibly silver.

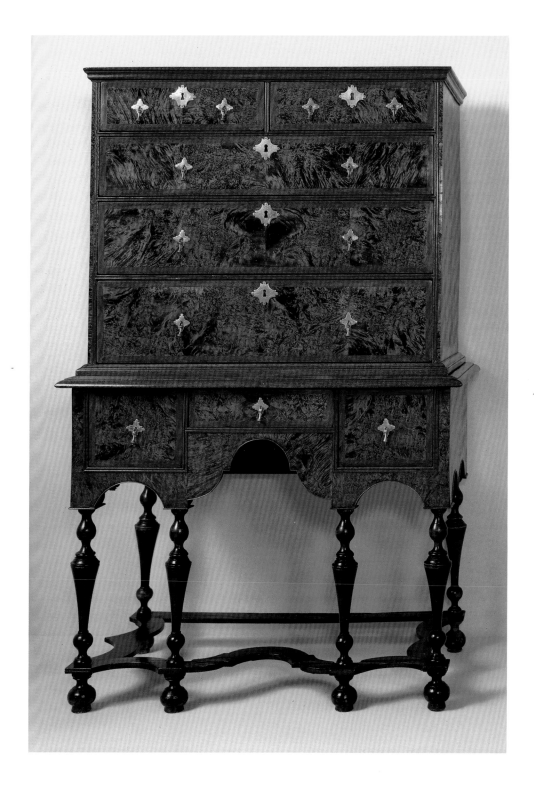

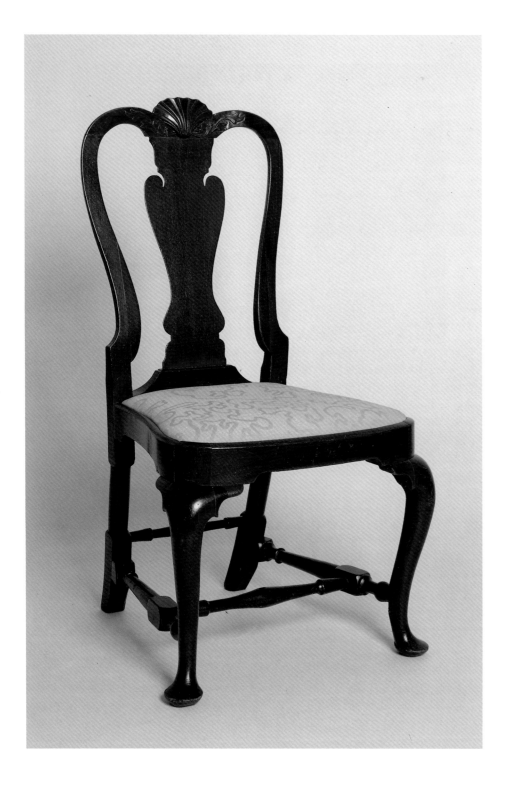

Side Chair, ca. 1740-60
American, Newport, Rhode Island, walnut, 39½ x 21¾ x 20¾ inches, purchase with funds from the Decorative Arts Endowment, 1988.225

In his 1742 essay "The Analysis of Beauty," the English artist William Hogarth wrote of the "line of beauty" as the idealized and elongated S-shape of the female form. That ideal shape is repeated over and over again in the construction of this Newport chair made at about the same time. The elongated S-shape occurs in the front legs, the side stiles of the back, the vase-form of the splat, and the shape of the seat. The maker repeated the serpentine shape in the vertical side profile of the chair.

The emphasis on curves and the solid back splat are characteristic of American interpretations of the late European Baroque in the mid-eighteenth century. The realistically carved shell at the center of the crest is a feature associated with Rhode Island design. The carved foliage on the crest flanking the shell is an unusual Rococo addition to the tightly drawn vertical frame of the chair. An original or old finish survives on the chair.

Dish, ca. 1745

Chinese export for the Dutch market, porcelain, 11¼ inches in diameter, purchase with funds from the Decorative Arts Endowment and the Decorative Arts Acquisition Trust, 1992.384

In the 1740s Holland was a major consumer of Chinese goods, and Amsterdam a main port in the China trade. Around 1745 the Snoeck family of Amsterdam ordered a porcelain dinner service, probably through the Dutch East India Company. Porcelain had been in production in Western Europe for only a little over two decades at about the time the service was ordered, so China was still the major source for porcelain in Holland. Armorial services like the Snoeck porcelain had to be special-ordered, and the time and expense involved were tremendous.

Although the material was Chinese, the forms and the decorations on this service were completely European. The scallop shape of the plate and the cornucopia and shell border may both have been derived from Dutch Delft prototypes. The Snoeck service is the only known armorial porcelain with this distinctive border. Incorporated into the Snoeck arms are two fish, a pun on the family name, which is Dutch for pike.

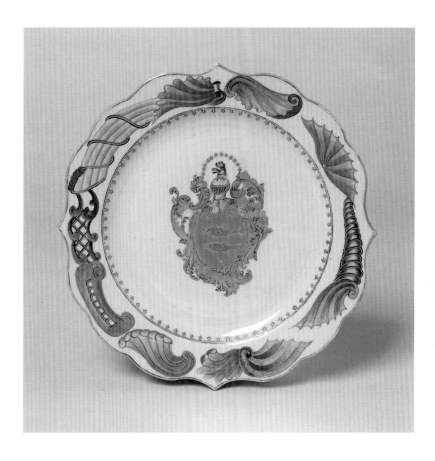

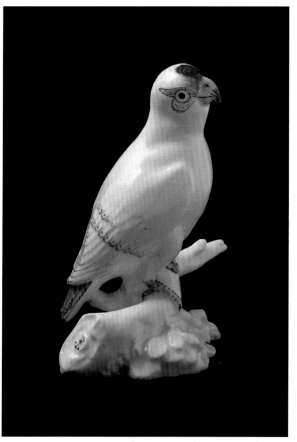

Parakeet, ca. 1752-53

Chelsea factory, England, soft-paste porcelain, 5 x 4¼ x 3¼ inches, Frances and Emory Cocke Collection, 1992.31

Chelsea was among the first successful English manufacturers of soft-paste porcelain. Realistically modeled birds perched on branches were favorite subjects for Chelsea table ornaments in the 1750s. The Cocke parakeet was based on an illustration from George Edwards's *Natural History of Uncommon Birds* (London, 1743-47). The parakeet seems to date from the period when the London artist William Duesbury (1725-1786) decorated Chelsea birds in his London atelier between 1751 and 1753.

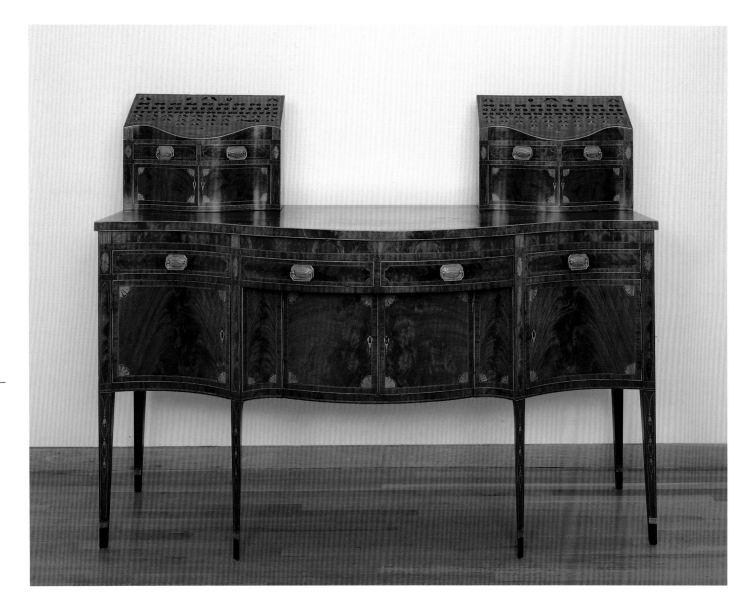

Sideboard with Matching Flatware Boxes, ca. 1794-99
William Whitehead, New York City, mahogany with lighter veneers over poplar; sideboard: 40$\frac{1}{8}$ x 72$\frac{1}{4}$ x 29 inches; flatware boxes: each 15$\frac{3}{4}$ x 22 x 9 inches, purchase with funds from a supporter of the Museum, 76.1000.5

In the early years of the Republic, domestic room use became more specific, and areas set aside for dining and entertaining were introduced into affluent American households. The sideboard, intended specifically for serving meals and storing utensils, linens, and liquor, was a new furniture form at this time. The Museum's sideboard, with highly figured veneers, delicate attenuating legs, and tight composition of straight and curved lines and surfaces, is characteristic of the finest American furniture of the Federal period. The rare original flatware boxes echo the form and decoration of the sideboard. The board retains fragments of the printed paper label of the New York cabinetmaker William Whitehead.

Sideboard, ca. 1800-1825

American, Athens area, Georgia, walnut,
yellow pine, 46 x 49½ x 22½ inches, gift of
Virginia Campbell Courts, 1977.1000.5

The tall and narrow proportions of this
sideboard link it with other known exam-
ples of furniture from the Georgia Pied-
mont. Used for serving, the sideboard
also afforded secure storage for valuables,
liquors, and foodstuffs. In the 1920s, col-
lectors often referred to this distinctive
southern form as a "hunt board." That
term, however, does not appear in early
nineteenth-century Georgia inventories,
advertisements, or other documents, and
this piece was probably called either a
sideboard or a slab. The square, tapering
legs are in the up-to-date neoclassical or
Federal style of the early nineteenth
century, but the ogee-shaped skirt is a
hold-over from the vocabulary of eight-
eenth-century American furniture design.

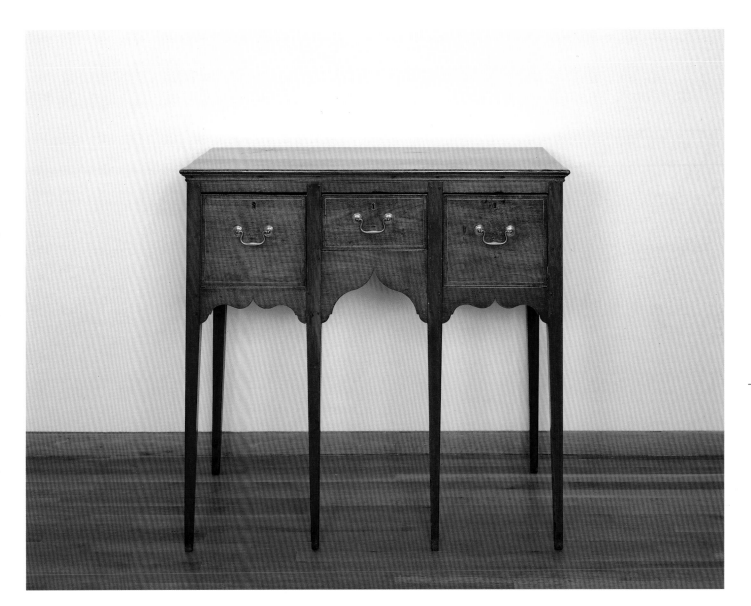

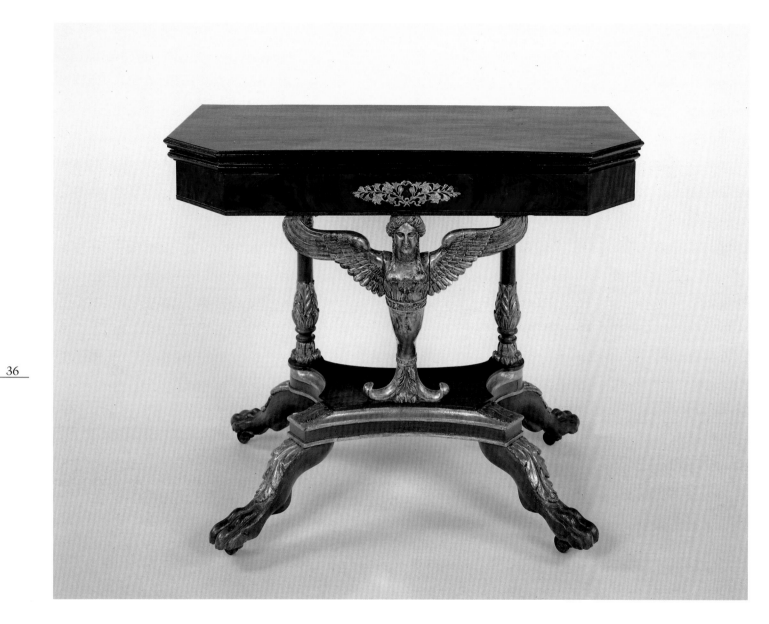

Card Table, ca. 1815
Charles Honoré-Lannuier (1774-1819), New York City, mahogany, mahogany veneer, gilt and antiqued gesso, gilt bronze, 30 x 36½ x 18½ inches, purchase with funds from the Decorative Arts Endowment, 1988.27

Charles Honoré-Lannuier trained in Paris and immigrated to New York City in 1804, where he worked the rest of his life. Lannuier was trained in the Empire style, and may have been instrumental in introducing this sophisticated French neoclassical taste to New York City. Fragments of his printed paper label survive on the bottom of the table.

The winged caryatid figure on the Museum's table is a feature seen on a number of Lannuier examples. Caryatid tables with known histories survive in Albany, New York, Baltimore, Maryland, and Richmond, Virginia. The gilt and glazed surface of the molded caryatid was intended to resemble antiqued bronze, and the green tint applied to the feet and other elements was also intended to suggest antiquity. The early history of the Museum's table is unknown; it was found in Louisiana, where it had been since at least the early twentieth century.

Couch, ca. 1820

American, Boston, Massachusetts, rosewood with gilt bronze mounts and inlaid brass (reproduction upholstery gift of Martha Cade), 34³/₄ x 76 x 23³/₄ inches, gift of the Forward Arts Foundation through the Decorative Arts Acquisition Trust, 1980.1000.6

The wealthy textile merchant and entrepreneur Nathan Appleton (1779-1861) constructed a brick mansion for his family on Beacon Hill in Boston between 1817 and 1819. The couch now in the High Museum of Art was part of the furnishings Appleton commissioned locally for his new home. Photos of the interior of the Appleton mansion taken in the 1880s show the couches in the parlor.

Philadelphia and New York City furniture was heavily influenced by the French emigré craftsmen working in those cities in the early nineteenth century. By contrast, Boston furniture tended to be conservative and largely followed English prototypes. The Boston maker of Appleton's couch might have been influenced by the designs published in Thomas Hope's *Household Furniture* (London, 1807). Though lacking the French flamboyance of New York City furniture, the restrained and elegant Appleton couch was richly executed in expensive tropical rosewood and decorated with ormolu mounts and inlaid brass.

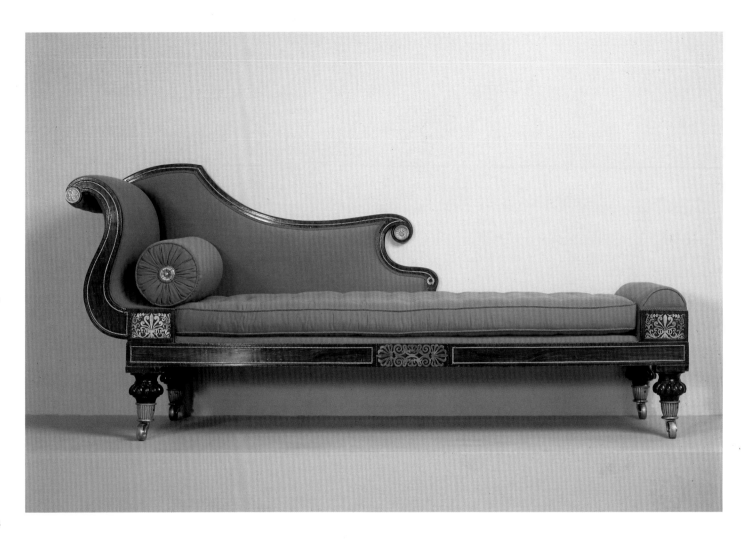

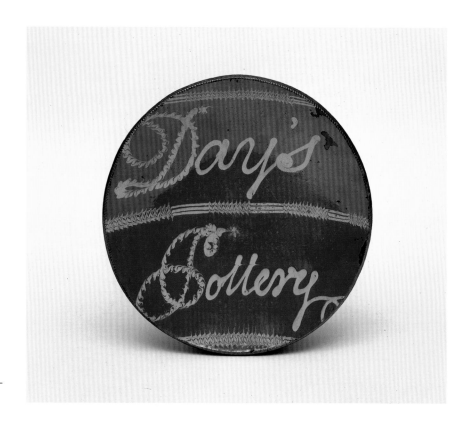

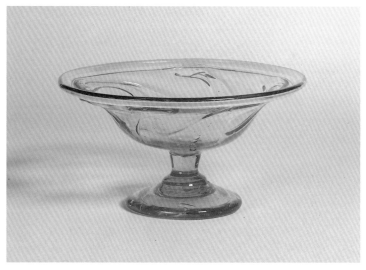

Charger, ca. 1794-1800

Absalom Day, Day's Pottery, Norwalk, Connecticut, slip-decorated redware, 15½ inches in diameter, purchase with funds from the Decorative Arts Endowment, 1992.76

Norwalk, Connecticut, was a major ceramic-making center in the first half of the nineteenth century. Absalom Day (1770-1843), who established one of the most successful and longest-surviving potteries in the region, probably trained in potting and decorating techniques in Philadelphia, where the craft was well-established by the time of the Revolution. By the mid-1790s Day had moved to Norwalk and was making red earthenwares at his own pottery, selling his products throughout the region as far away as New York City. Day has been credited with introducing Philadelphia techniques of molding and slip-decorating red earthenware to Norwalk, influencing several generations of potters in the vicinity.

This unusually large and decorative charger may have served as a shop sign. It is decorated with a slip inscription that has been both combed and curled; the yellow writing was applied as liquid clay, rather like frosting on a cake, before the charger was covered in its shiny lead glaze. Impressed on the back is "AWJ," perhaps the initials of the potter in Day's employ who made the charger.

Compote, ca. 1835-1865

American, probably upstate New York, blown non-lead glass, 5 x 9¼ x 9¼ inches, purchase with funds from the Decorative Arts Endowment, 1993.24

This compote was free blown; then a second layer of molten glass was applied to the outside, tooled, and drawn up into symmetrical scrolls while still in a hot liquid state. To manipulate molten glass in this fashion took great control and dexterity. Prototypes for so-called "lily-pad" glass wares exist in eighteenth-century Europe, but how these became a part of nineteenth-century American glass vocabulary is unknown. Most examples were made from unrefined non-lead glass, indicating they were made in factories that made window-glass and bottles rather than high-style lead glass table wares. However, "lily-pad" pitchers and other forms like this compote survive in high enough numbers to indicate they must have been desired and profitable items, and not end-of-the-day whimseys made for the glass blowers' amusement and personal use.

Sugar Bowl, ca. 1815-1840

American, Pittsburgh, Pennsylvania, blown and molded lead glass, 6³/₄ x 4 x 4 inches, purchase with funds from the Decorative Arts Acquisition Trust, 1981.1000.9

Free-blown and patterned in a twelve-rib mold, this sugar bowl is of a type often associated by early collectors with "Bakewell bowls." Though no documentary evidence links this bowl with Bakewell, the well-known nineteenth-century Pittsburgh glass-making company, the form and distinctive blue-purple color are typical of the wares believed to have been produced there in the early nineteenth century. The bowl was included in a landmark Girl Scout exhibition of American furniture and glass in New York in 1929, when it was part of the collection of the pioneer American glass dealer and scholar George S. McKearin.

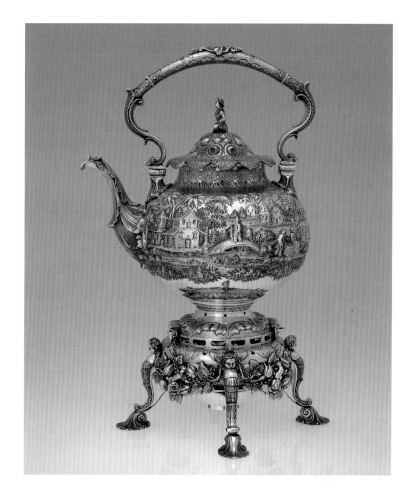

Hot Water Kettle on Stand, 1850s

Bailey and Company, Philadelphia, Pennsylvania, silver; kettle: 16¹/₂ x 10¹/₂ x 8 inches; stand: 4¹³/₁₆ x 10 x 10 inches; burner: 3 x 3³/₄ x 3³/₄ inches, Virginia Carroll Crawford Collection, 1993.138 a-c

Located in the heart of Philadelphia's most prestigious shopping district on Chestnut Street, Bailey and Company was one of America's premier emporiums for jewelry, silver, and luxury goods in the 1850s. Undoubtedly originally from a large tea service, the Museum's kettle matches a set now in the National Museum of American History at the Smithsonian Institution. Both sets appear to match a set Bailey and Company exhibited at the Crystal Palace Exhibition in New York City in 1853.

The kettle's round shape, repoussé decoration, ogee spout, double-ogee handle, and stand with elaborate cast caryatid-figured legs with scroll terminals closely followed eighteenth-century Philadelphia and London prototypes. The fully realized Rococo Revival style illustrated in the kettle coincided with the popularity of carved and laminated furniture by John Henry Belter.

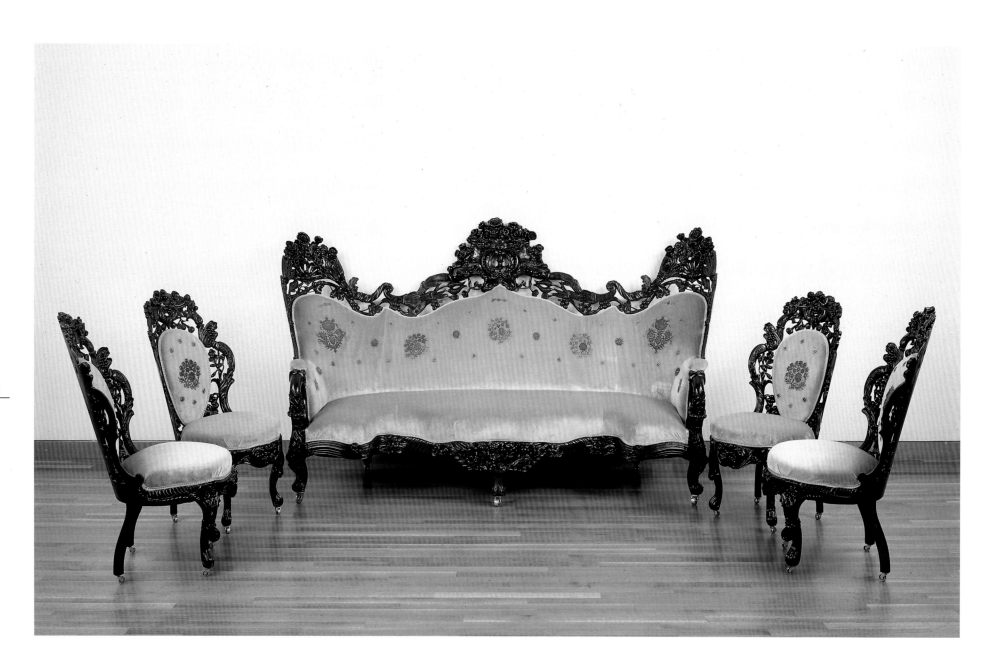

Sofa and Side Chairs, ca. 1855

Attributed to John Henry Belter, New York City, laminated and carved rosewood, white pine, ash, gilt brass castors, original appliqué medallions on silk plush velvet; sofa: 51½ x 91¾ x 38½ inches; side chair: 39⅞ x 19⅛ x 27½ inches, Virginia Carroll Crawford Collection, 1981.1000.61-.65

German emigrant John Henry Belter patented a process of laminating wood sheets to create the curved backs on the carved furniture made in his New York factory in the 1850s. Although the technique was imitated and adapted by many manufacturers at the time, Belter's name survives as a kind of generic term for furniture in this elaborate and convoluted Rococo Revival style. The silk velvet upholstery is an identical modern replacement of the original. The surviving medallions, embroidered in silvered threads, have been re-applied in their original configuration. Following mid-nineteenth-century custom, the sofa and chairs were part of an extensive parlor set which might have included other sofas and settees, chairs, tables, étagères, and cabinets.

Century Vase, 1876

Designed by Karl Müller, Union Porcelain Works, Green Point (Long Island), New York, porcelain, glazed and bisque with gilt decoration, 22½ x 12 x 12 inches, Virginia Carroll Crawford Collection, 1986.163

A pair of robust monumental vases were made by the Union Porcelain Works to celebrate the first century of American independence. In the summer of 1876, the vases were shown at the Centennial Exhibition in Philadelphia's Fairmont Park. Like the international fair itself, the vases not only commemorated the founding of the nation, but celebrated the technological progress of its first century, linking historical events like the Boston Tea Party and William Penn's Treaty with the Indians (here depicted in biscuit) with such innovations as Fulton's steamboat and the telegraph (shown in polychrome). The American eagle, George Washington, and heads of native American animals carry out the elaborate American themes. The mate to this vase is in the Brooklyn Museum.

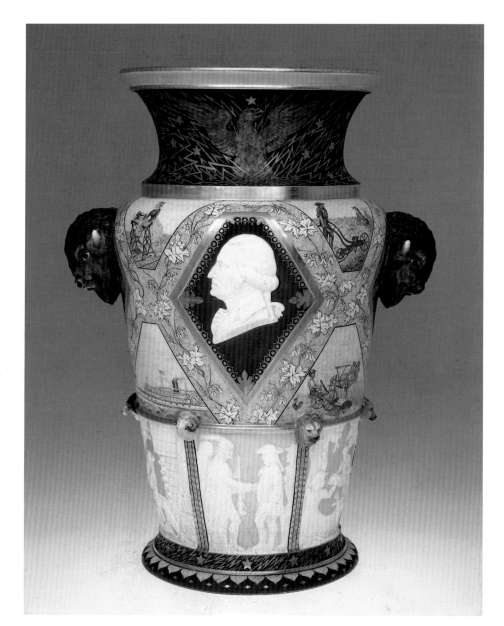

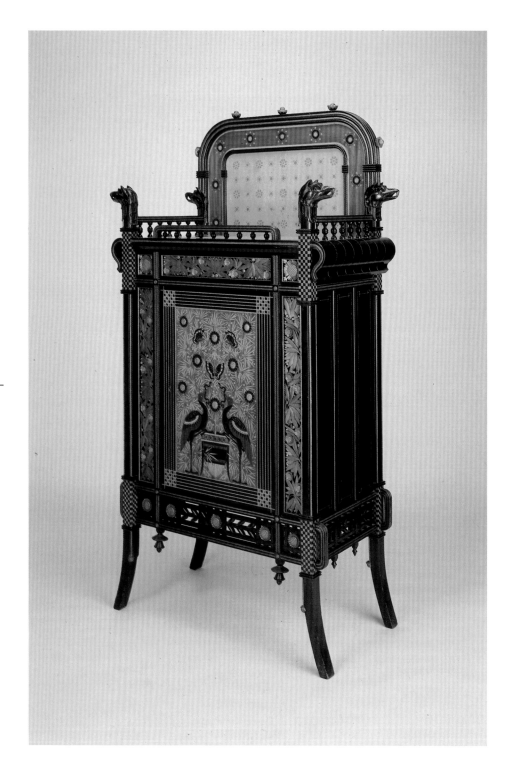

Cabinet, ca. 1880

Herter Brothers, New York City, ebonized cherry, marquetry of lighter woods, gilt decoration, 60 x 33 x 16¼ inches, Virginia Carroll Crawford Collection, 1981.1000.51

Herter Brothers was a leader among the many interior decorating firms flourishing in New York City during the late nineteenth century. Wealthy and worldly patrons commissioned singular examples of "Art Furniture," a Herter specialty. The integration of pattern with form and the distinctive marquetry door in the refined Japanese mode illustrate the firm's introduction of sophisticated English "Aesthetic Movement" visions into American taste during the 1880s. A cabinet of the same shape and pattern, executed in lighter woods, but unmarked, is at Sagamore Hill, the Long Island residence of Theodore Roosevelt. It was made for his parents' New York City home.

Vase, ca. 1900

Tiffany and Company, New York City, silver, copper, turquoise, 7½ x 8¾ x 9 inches, Virginia Carroll Crawford Collection, 1984.170

The sources of eclectic American taste in the early twentieth century were varied. American Indian design inspired several works executed by Tiffany and Company at the time. This geometric pattern in copper and silver is reminiscent of Southwestern Indian basket design. The handles, in the form of snake heads, recall American Indian jewelry traditions. The simple angular patterns of Native American inspiration fit with the tenets of the Arts and Crafts Movement in America and were a precursor of the angular American design of the 1920s. The vase was made for exhibition at the 1900 Paris Exposition Universelle and was again exhibited by the firm at the 1901 Pan-American Exposition in Buffalo, New York.

Vase, 1901

Decorated by Grace Young, Rookwood Pottery, Cincinnati, Ohio, earthenware, 14½ x 6¼ x 6¼ inches, Virginia Carroll Crawford Collection, 1993.129

The Rookwood Pottery was the most enduring and commercially successful American art pottery of the Arts and Crafts period. Grace Young was one of the firm's most highly regarded artists. In the late 1890s and at the beginning of the twentieth century, Young became particularly well-known for her portraits of Native Americans on Rookwood vases. Her portrait of Pablino Diaz Kiowa is remarkable because of its monumental height. It is one of the few Rookwood Native American portrait vases to depict its subject at full figure rather than as a bust rendering.

Grace Young must have considered the Museum's vase a significant example of her work; she presented it to Edwin Atlee Barber (1851-1916), the pioneer scholar of American ceramics. Barber published the vase as representing the outstanding work of Rookwood in his landmark study, *The Pottery and Porcelain of the United States.*

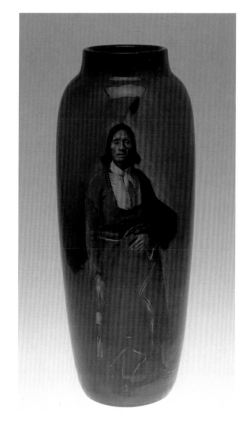

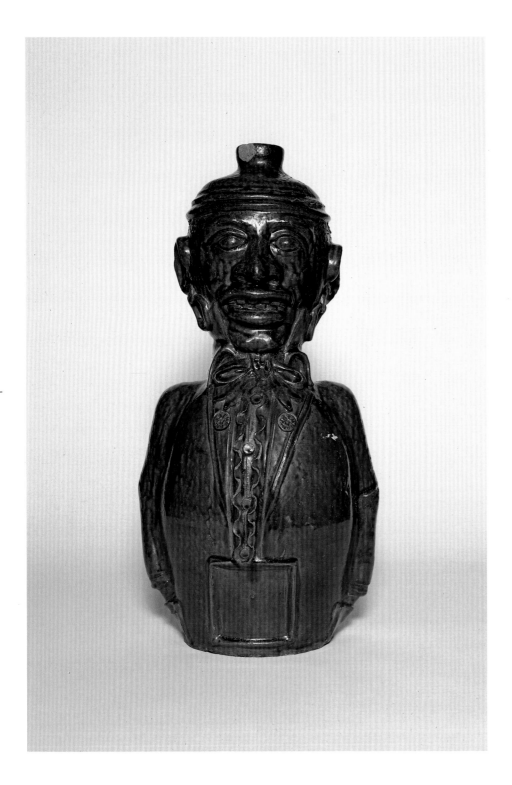

Figural Jug, 1860-80
John Lehman, Randall Mill, Randolph
County, Alabama, ash-glazed stoneware,
23³/₄ x 11¹/₂ x 10³/₄ inches, purchase with
funds from the Decorative Arts Endowment,
1994.19

Born in Germany, John Lehman was
operating a pottery in Randolph County,
Alabama, as early as 1860, according to
census records. Lehman's jug is one of
the largest and most vivid and elaborate
characterizations on a figural vessel by
a nineteenth-century southern potter.

The identity of the African male
depicted in the jug is unknown. The tight-
fitting stocking cap and presumably gold
earrings combine with a beautifully mod-
eled tie, ruffled shirt, and well-tailored
coat to convey the character of a figure
both dashing and dangerous.

Lehman cleverly signed his jug by
impressing his name on the buttons of the
coat his figure is wearing. The rectangle
molded at the front just below the chest of
the figure must have originally framed a
paper label identifying the contents of the
jug. While Lehman is known to have
worked into the 1880s, the stylish clothes
of the figure would have been fashionable
in the 1860s.

Blanket Chest, 1900-20

African-American community, Savannah, Georgia, yellow pine, cedar, 29 x 48 x 30 inches, purchase with funds from the Decorative Arts Endowment, 1991.284

This blanket chest was meticulously crafted and lined with cedar to protect blankets and other textiles. The general shape may have been based on illustrations of trunks from mail-order catalogues at the turn of the century. Distinctive and elaborate non-representational chip carvings and stacked moldings cover the entire surface of the chest. The incised, dotted, and carved decorations on the chest are reminiscent of those on a door from the Ivory Coast in the Fred and Rita Richman Collection of African Art in the High Museum. The unidentified African-American maker of the chest is believed to be also responsible for a hall stand and mirror based on an early twentieth-century oak prototype and covered in the same type of decoration.

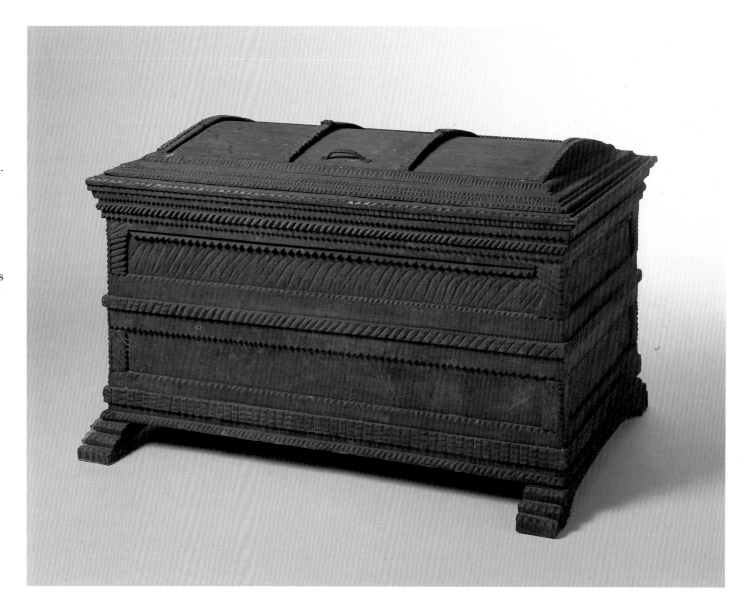

45

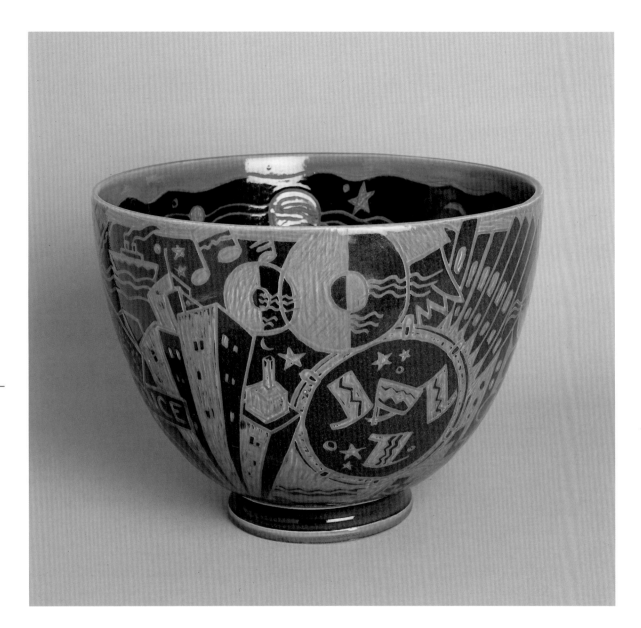

Jazz Punch Bowl, 1931

Viktor Schreckengost (born 1906), Cowan Pottery Studio, Rocky River, Ohio, porcelain with incised slip decoration, 12 x 16½ x 16½ inches, purchase with funds from the Decorative Arts Endowment, 1993.13

The Museum's *Jazz Bowl* is one of ten made under the supervision of the artist and designer Viktor Schreckengost. The first was commissioned by Eleanor Roosevelt (1884-1962) in 1931, when she was First Lady of New York, for use in the Governor's Mansion in Albany. Mrs. Roosevelt was seeking an object expressing New York City on New Year's Eve.

Schreckengost used Cowan Pottery's distinctive "Egyptian blue" to execute the bowl because the color reminded him of the city lights reflected on a night sky. The inscriptions, including "jazz," "dance," "cafe," and "follies," together with motifs of the New York skyline, cocktail glasses, and dancers, all convey the sense of celebration Mrs. Roosevelt was seeking in a Depression year.

Desk and Chair, 1936-39

Designed by Frank Lloyd Wright, Steelcase, Inc., Grand Rapids, Michigan, "Cherokee" red enamelled steel and walnut; desk: 33½ x 84 x 35 inches; chair: 34½ x 23½ x 19½ inches, purchase with funds from the Decorative Arts Endowment, 1984.371.1-.2

Frank Lloyd Wright first achieved fame as the foremost American architect of the twentieth century with his designs for "Prairie School" houses at the turn of the century. In the 1930s, with his career in the doldrums, Wright was commissioned to design the S. C. Johnson Administration Building in Racine, Wisconsin. The metal office furniture he created for the great workroom in the Administration Building reflected the overall form of the structure. The international acclaim which the Administration Building and its furnishings received re-established Wright's prominence and led to a third phase in his career, which culminated in the Solomon R. Guggenheim Museum building in New York City.

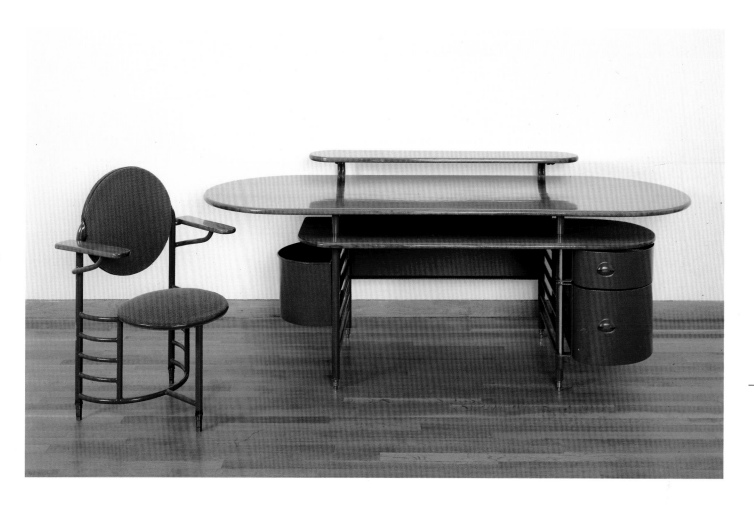

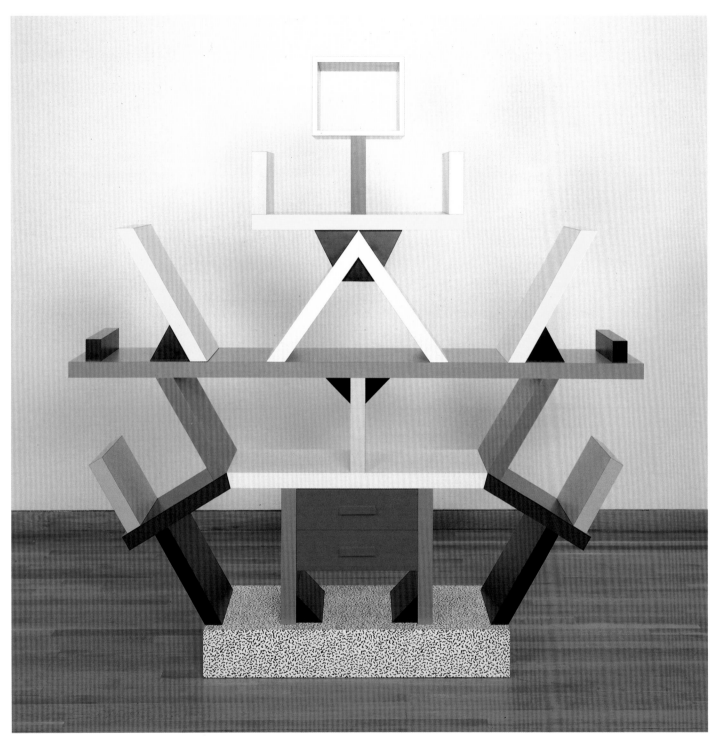

"Carlton" Room Divider, 1981
Designed by Ettore Sottsass, for Memphis, Milan, Italy, plastic laminate, 77 x 74³/₄ x 18¹/₄ inches, purchase with funds from the Decorative Arts Acquisition Trust and funds raised by David G. Hayes, 1986.49

At the Furniture Fair of Milan in 1981 a group of internationally known designers calling itself "Memphis" premiered its initial line of furniture and accessories. The premier was a challenge to what the group perceived as a lack of innovation and inspiration in the designs of the 1970s. Though functional, the furniture demanded attention for its aggressive sculptural qualities and its radical use of modern industrial materials and bright colors. Veneered in laminate plastic, the "Carlton" was constructed by methods demanding time-consuming and costly hand labor.

EDWARD MOULTHROP
American, born 1916

Spheroid Bowl, 1990
Ash-leaf maple, 11¼ x 13½ x 13½ inches,
purchase with bequest of Lucia Peeples
Fairlie, 1990.55

An Atlanta artist of international renown,
Ed Moulthrop is considered one of the
founders of the turned wood movement in
contemporary craft. Moulthrop is partic-
ularly known for his elegant shapes and
technically perfect surfaces, executed in
beautifully grained woods indigenous to
the American South.

Moulthrop has been turning wood since
childhood. His first connection with the
High Museum of Art was as the architect
of its 1955 building. In 1970, when he had
given up architecture to turn wood full
time, a giant Moulthrop bowl was among
the first purchases for the High Museum
of Art's decorative art collection.

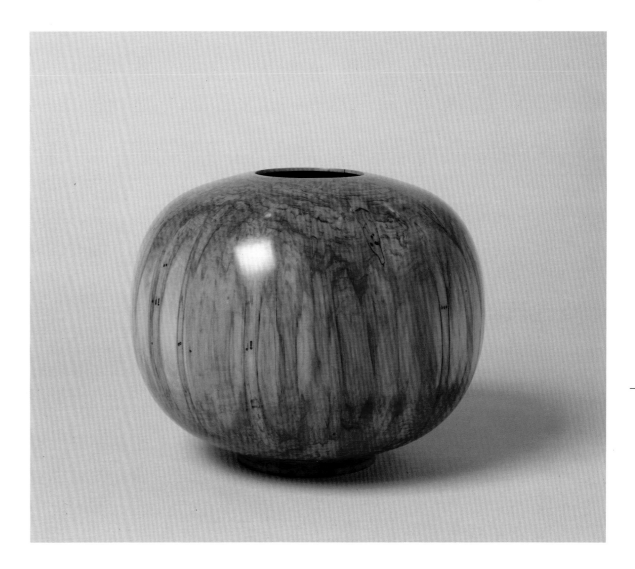

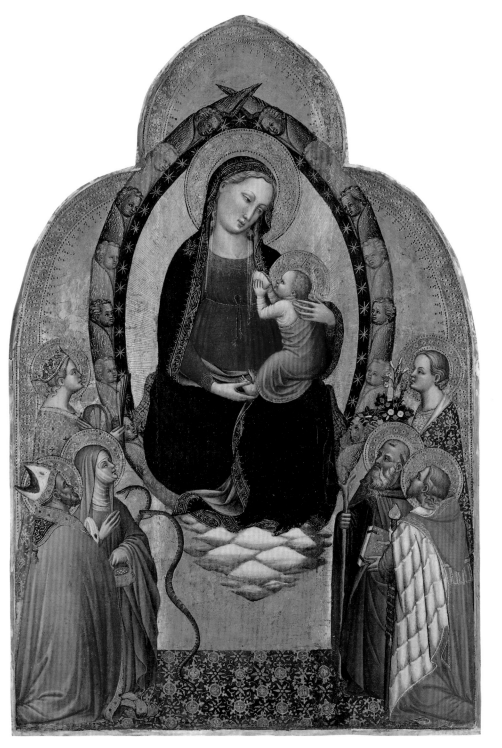

THE MASTER OF THE
ST. VERDIANA PANEL
Italian, active 1390-1415

*Madonna and Child with Six
Saints*, ca. 1390
Tempera on panel, 31¾ x 21⅜ inches, gift of
the Samuel H. Kress Foundation, 58.49

The Master of the St. Verdiana Panel was
an anonymous Florentine painter named
for the High Museum's panel, which
portrays the rarely depicted St. Verdiana,
represented as a nun holding a basket. The
thirteenth-century saint is shown with
two snakes, her distinguishing attribute,
which recall her life as a recluse, tor-
mented by serpents.

Pictured with St. Verdiana are five
other adoring saints. On the same side
as St. Verdiana are St. Nicholas in his
bishop's robe and mitre and the crowned
St. Catherine of Alexandria with a wheel,
the instrument of her martyrdom. At the
right are St. Julian, patron of innkeepers,
travelers, and boatmen, the bearded St.
Anthony Abbot, with a book and staff,
and St. Dorothy, who holds roses and
lilies of purity. The Virgin sits on a body
of clouds nourishing the infant Christ.
Enclosed within a glorious mandorla
adorned with seraphim and cherubim, the
Mother and Child appear as a vision to
the reverent saints.

FRANCESCO DI GIORGIO
Italian, 1439-1502

The Nativity, ca. 1460-65
Tempera on panel, 9³/₈ x 8³/₄ inches, gift of
the Samuel H. Kress Foundation, 61.42

Francesco di Giorgio was one of the few
fifteenth-century Sienese artists famous
throughout Italy. He was an architect and
sculptor as well as a painter and was a
valued court artist at Urbino and Naples.
With its minimal use of gold, introduc-
tion of a landscape background, and inclu-
sion of anecdotal details, such as the ox
and ass feeding at the manger, the sweet,
delicate style of this painting evinces a
new naturalism in Italian art.

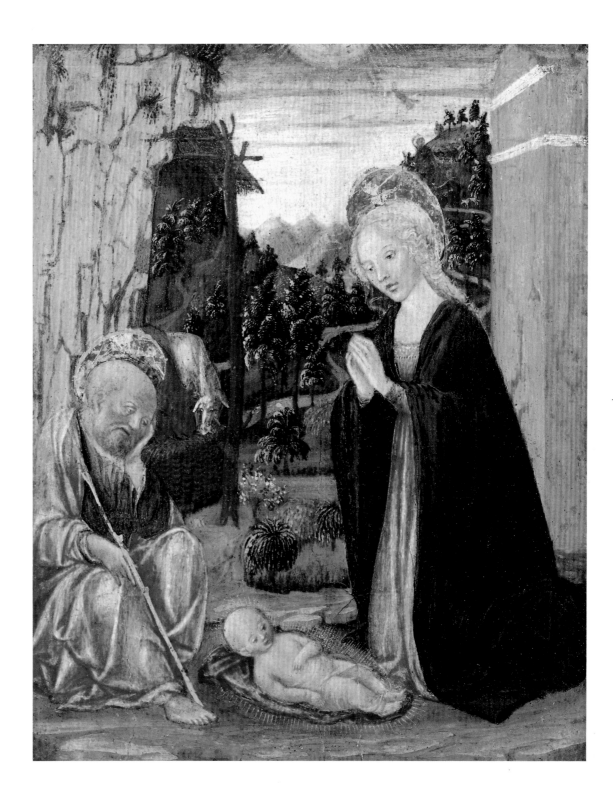

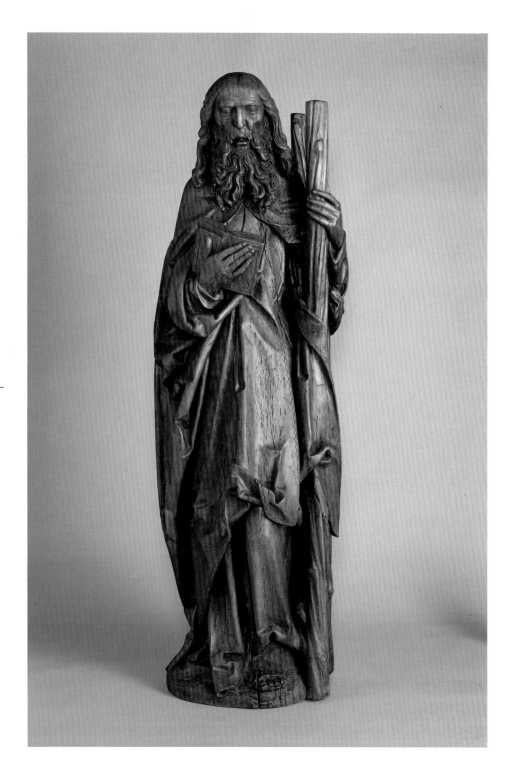

TILMANN RIEMENSCHNEIDER
German, ca. 1460-1531

St. Andrew, ca. 1505
Lindenwood, 40½ x 13½ x 8¼ inches, gift of
the Samuel H. Kress Foundation, 58.57

Tilmann Riemenschneider, the greatest
late medieval German sculptor, was
remarkable not only for his technical
facility but also for the expressive power
of his figures. St. Andrew, who holds the
X-shaped cross of his martyrdom, has
the elongated hands and face and intense
expression that are typical of late Gothic
art. A brown stain has been applied to the
natural lindenwood, perhaps in the late
nineteenth century, in order to simulate
oak. The piece was probably polychromed
originally.

GIOVANNI BELLINI
Italian, ca. 1426-1516

Madonna and Child, ca. 1510
Oil on panel, 37⅛ x 28¾ inches, gift of the
Samuel H. Kress Foundation, 58.33

Giovanni Bellini, the teacher of Giorgione
and Titian, was the foremost Venetian
painter of the early Renaissance. He made
a specialty of painting the Madonna and
Child before a landscape. Here, the figures
appear before a symbolic cloth of honor
which separates the divine from the
naturalistic scene in the background.
The single bare tree probably alludes to
Christ's cross and the arid state of man-
kind before salvation, as well as to the
tree in the Garden of Eden which led to
the downfall of man. The balustrade with
Bellini's signature separates the mortal
viewer from the holy figures and under-
lines the iconic aspect of the image.

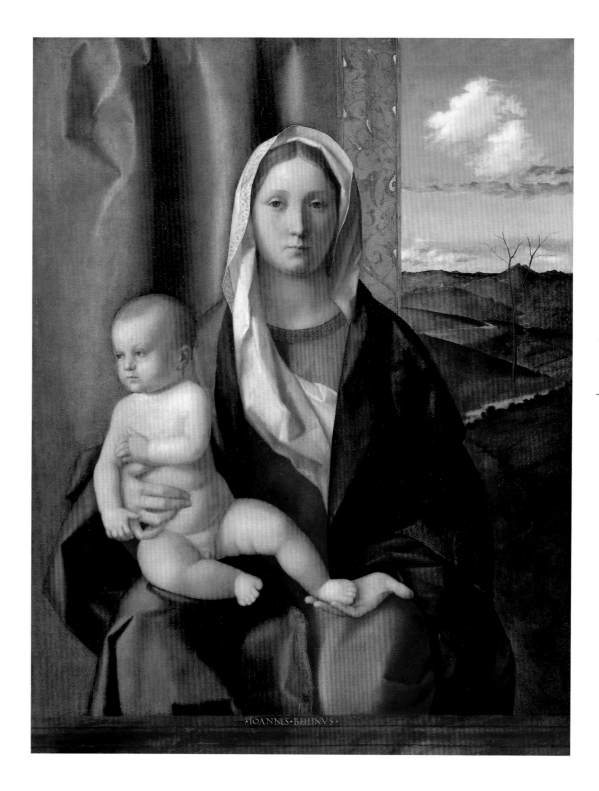

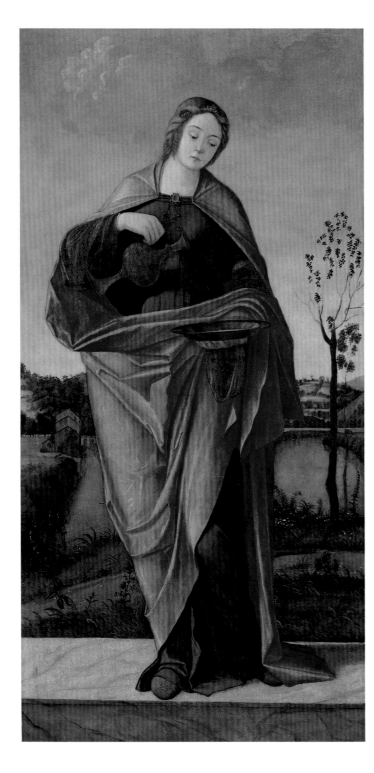

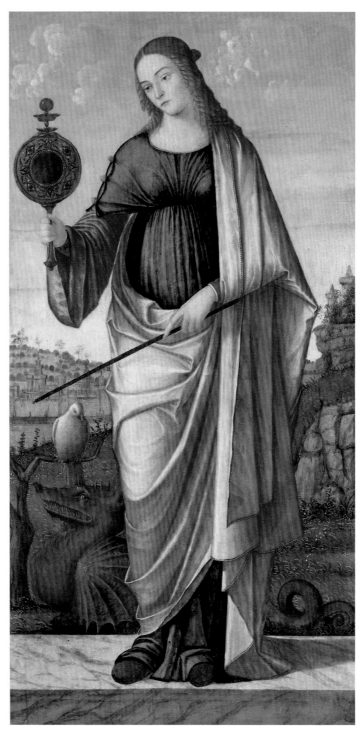

VITTORE CARPACCIO
Italian, ca. 1460-ca. 1526

Temperance, ca. 1525
Oil on panel, 42⅝ x 21⅝ inches

Prudence, ca. 1525
Oil on panel, 42⅝ x 21¾ inches, gifts of the
Samuel H. Kress Foundation, 58.35 and 58.36

The Venetian-born Vittore Carpaccio,
influenced by Giovanni Bellini, exhibited
a striking sensitivity to light, color, and
landscape.

Carpaccio's *Temperance* and *Prudence*–
probably from a set of the Four Cardinal
Virtues–are represented as women, each
with her distinguishing attributes. Tem-
perance is shown carefully pouring liquid
from one vessel into another, probably
diluting wine as a symbol of moderation.
Prudence, representing wise and judicious
conduct, is depicted holding a mirror, a
reminder that the prudent are capable of
truthful self-examination and provident
reflection on the present and the future.
The open, ethereal landscapes behind the
figures emphasizes the serenity and mod-
esty of the two Virtues.

LUCAS CRANACH THE ELDER
German, 1472-1553

Portrait of Duke Henry the Devout of Saxony, 1528

Oil on panel, 22½ x 15¼ inches, gift of Mrs. Irma N. Straus in memory of her husband, Jesse Isidor Straus, 63.5

One of the masters of the German Renaissance, Lucas Cranach adopted the name of his birthplace, Kronach. He was a follower and friend of Martin Luther and a strong defender of the Protestant Reformation. He worked for three years in Vienna for the Hapsburg Emperor Maximilian I, becoming famous for his woodcuts and his paintings, especially portraits. In 1505 Duke Frederick the Wise of Saxony called Cranach to Wittenberg, where he remained for the rest of his life as court painter.

Cranach made several portraits of Henry the Devout (1473-1541), one of Frederick's successors, including full-length versions in 1514 and 1537. In the High Museum's painting, the sturdy torso and powerful head with carefully delineated features convey the Duke's forceful character. The hands were probably painted by a studio assistant.

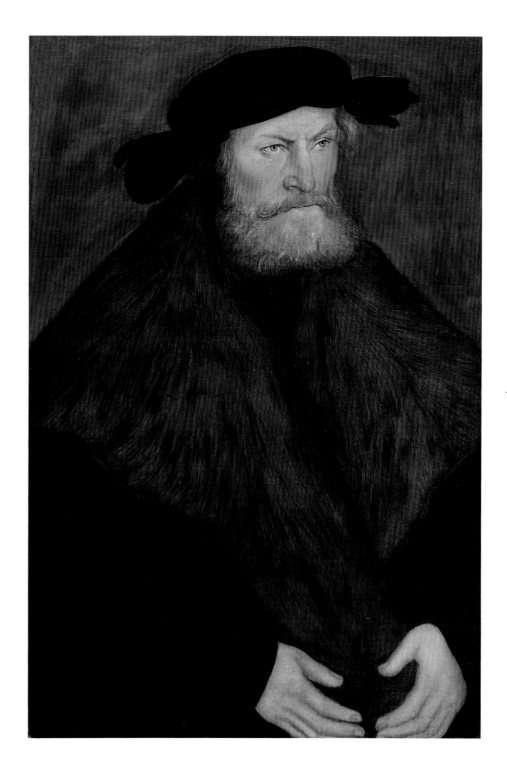

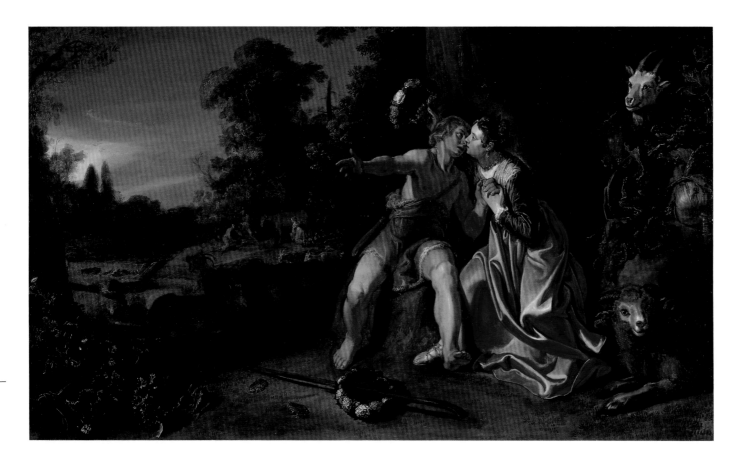

PIETER LASTMAN
Dutch, ca. 1583-1633

Paris and Oenone, 1610

Oil on panel, 25³/₄ x 43³/₄ inches, purchase in honor of Thomas G. Cousins, President of the Board of Directors, 1987-1991, with funds from Alfred Austell Thornton in memory of Leila Austell Thornton and Albert Edward Thornton, Sr., and Sarah Miller Venable and William Hoyt Venable, 1990.57

Pieter Lastman, Rembrandt's teacher, was the most important history painter active in Amsterdam in the early decades of the seventeenth century. The rare subject of this painting, identifiable by the inscription on the tree behind the lovers, is taken from Ovid. Oenone begs her husband, Paris, not to leave for Troy. Her sense of foreboding was prophetic: Paris's abduction of Helen led to the Trojan War, Paris's death, and Oenone's subsequent suicide. This is perhaps the earliest pastoral landscape in Dutch art.

JAN BRUEGHEL THE ELDER
Flemish, 1568-1625
and unknown collaborator

Garland of Flowers with Holy Family, ca. 1620

Oil on panel, 28³/₄ x 23¹/₄ inches, purchase with funds from Alfred Austell Thornton in memory of Leila Austell Thornton and Albert Edward Thornton, Sr., and Sarah Miller Venable and William Hoyt Venable, 1989.113

This painting is the result of a collaboration between Jan Brueghel the Elder– nicknamed "Flower" for his floral still lifes and "Velvet" for his refined brushwork–and an unknown collaborator from Rubens's circle, who painted the figures. Jan Brueghel's flower garlands were highly prized by seventeenth-century collectors. The beautifully painted flowers signal the preciousness of the sacred image they surround and concentrate the viewer's attention on the figures. Flowers, especially the lily, the iris, and the rose, symbolize the Virgin's purity and divinity.

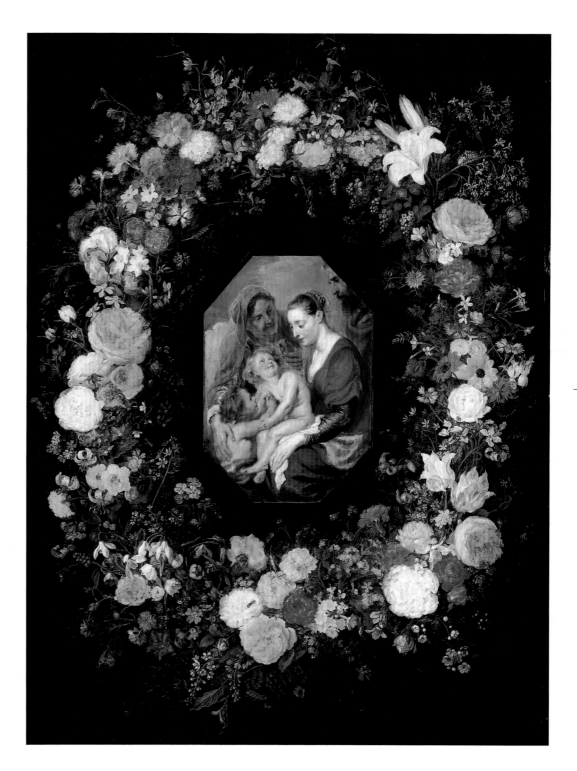

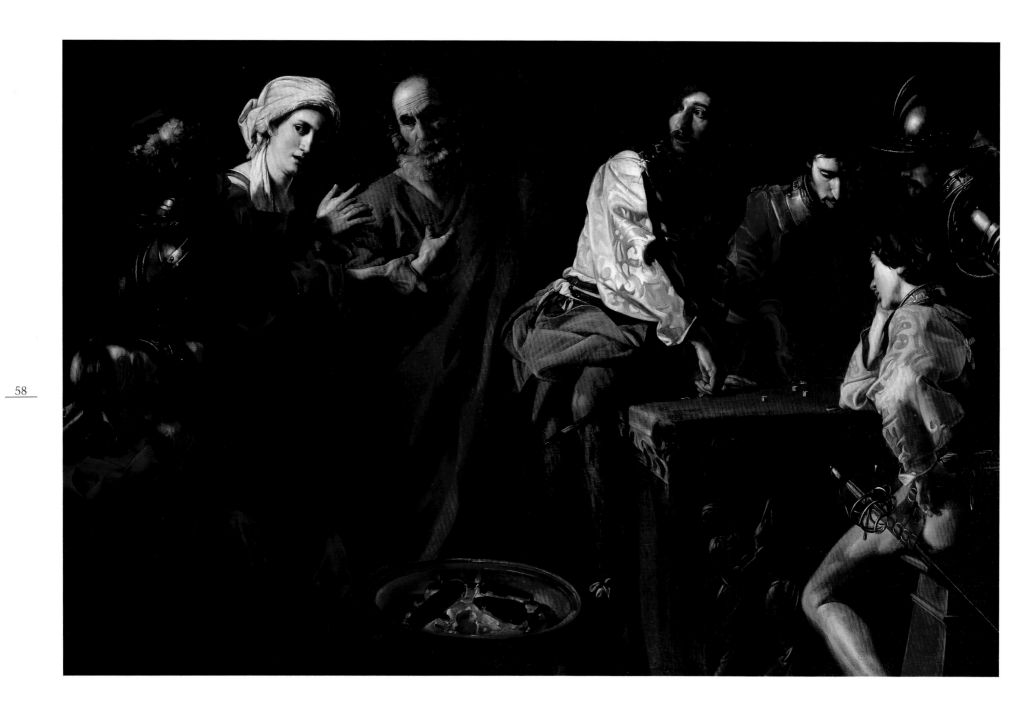

NICOLAS TOURNIER
French, 1590-1638/39

The Denial of St. Peter, ca. 1630
Oil on canvas, 63 x 95 inches, gift of the
Members Guild in honor of its 20th anni-
versary and in memory of Mr. Robert W.
Woodruff on the occasion of the 100th
anniversary of Coca-Cola, 1986.52

The French painter Nicolas Tournier spent
the years between 1619 and 1626 in Rome,
where he was influenced by the work of
the Italian Baroque painter Caravaggio.
This painting depicts Peter's moment
of spiritual crisis as he denies Jesus.
Although Tournier's use of light and shade
to heighten the emotional intensity and
pathos of the New Testament scene is
reminiscent of Caravaggio's style, the
graceful figures and lyrical composition
are emblematic of the seventeenth-
century French school. Works by Tournier
are rare because many of his paintings
were lost or destroyed during the French
Revolution.

REINIER NOOMS, CALLED "ZEEMAN"
Dutch, ca. 1623-1664

A View of the Amsterdam Harbor, after 1640
Oil on canvas, 25 x 30³/₄ inches, gift of the
Walter and Frances Bunzl Foundation,
1991.300

Judging by Reinier Nooms's signature
("Zeeman" or "seaman") and the books on
navigation listed in his widow's inventory,
it is probable that this artist had firsthand
knowledge of the sea. This painting, with
its dominant sky and majestic ships, rep-
resents the "monumental" phase of seven-
teenth-century Dutch landscape and
seascape painting. The ships have been
depicted so accurately that they can be
identified: the ship with the sun on its
bow in the middle ground is "De Zon,"
built in Amsterdam in 1640, and the large
merchant ship with a country house and
drawbridge on the left is probably the
"Wulpenburg." The well-armed ship at the
right displays the Amsterdam admiralty
flag in addition to the Dutch flag. The ves-
sels are sitting high in the water because
their cargo has already been unloaded;
Zuider Zee channels were not deep
enough for heavily laden ships to dock at
Amsterdam. Others rest on their sides,
being de-barnacled and retarred.

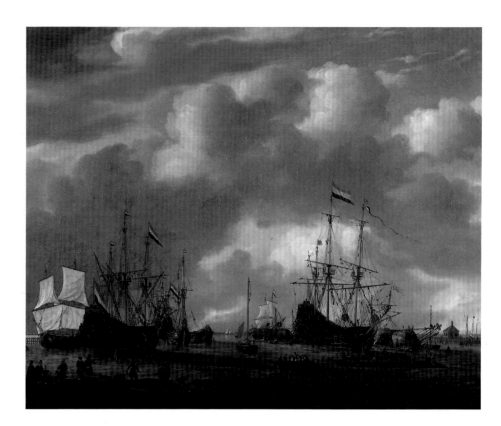

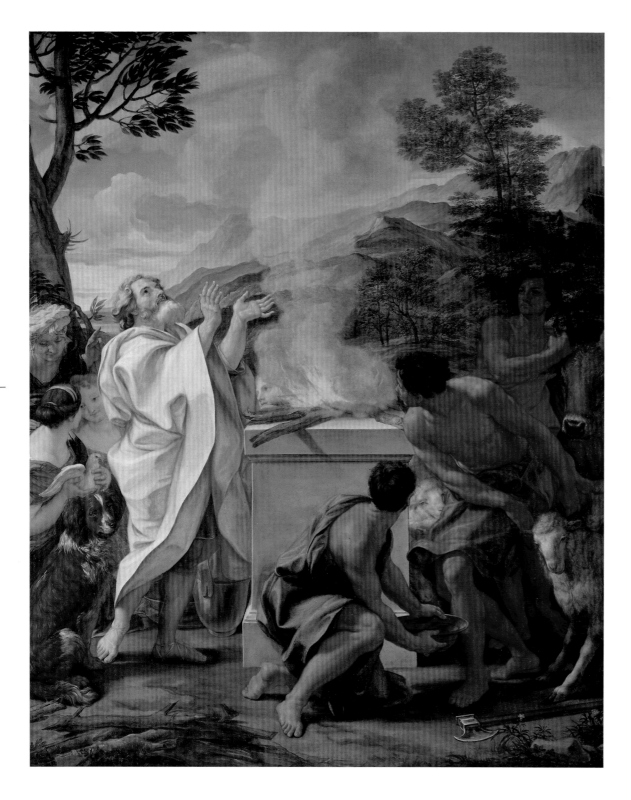

GIOVANNI BATTISTA GAULLI, CALLED BACICCIO
Italian, 1639-1709

The Thanksgiving of Noah,
ca. 1685-90
Oil on canvas, 64½ x 51¼ inches, gift of the
Samuel H. Kress Foundation, 58.30

The Genoese artist Giovanni Battista
Gaulli arrived in Rome in the 1650s and
was soon befriended by the great sculptor
Gian Lorenzo Bernini, who recommended
the younger artist to his own influential
patrons. In 1672 Baciccio was commis-
sioned to paint the frescoes for the dome
and vaults of the mother church of the
Jesuits in Rome, Il Gesù.

Completed during Baciccio's mature
Roman period, these two companion
paintings were probably intended for
altars. Each deals with an Old Testament
story of sacrifice that was regarded as
prefiguring the death and resurrection
of Christ.

After surviving the great flood, Noah
built an altar on which to sacrifice every
clean living beast. Baciccio's painting
depicts Noah and his family offering their
thanks. The rainbow in the heavens repre-
sents God's covenant with man never
again to destroy the earth by flood.

GIOVANNI BATTISTA GAULLI, CALLED BACICCIO
Italian, 1639-1709

Abraham's Sacrifice of Isaac,
ca. 1685-90

Oil on canvas, 63¼ x 51⅝ inches, gift of the
Samuel H. Kress Foundation, 58.31

The theme of sacrifice is repeated in
Abraham's Sacrifice of Isaac. When
Abraham demonstrates his unshakeable
faith by preparing to sacrifice his only
son, God sends an angel to intervene.

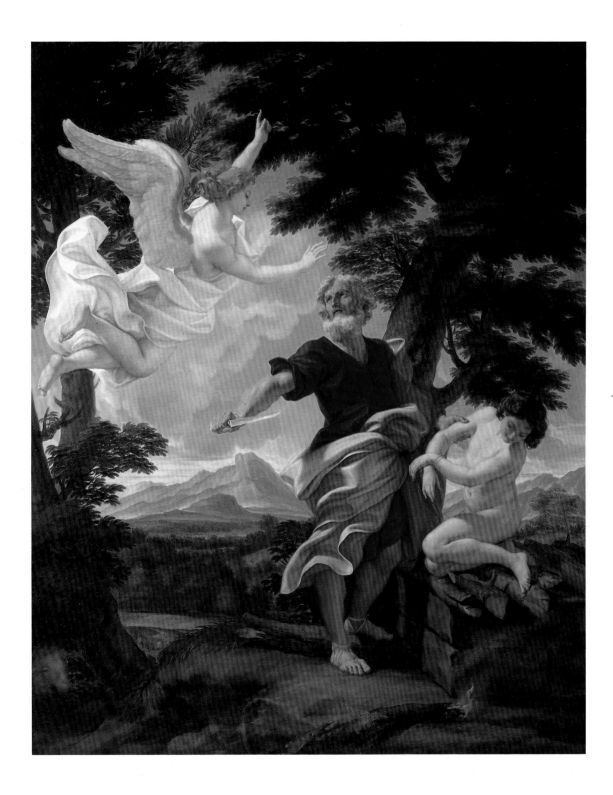

61

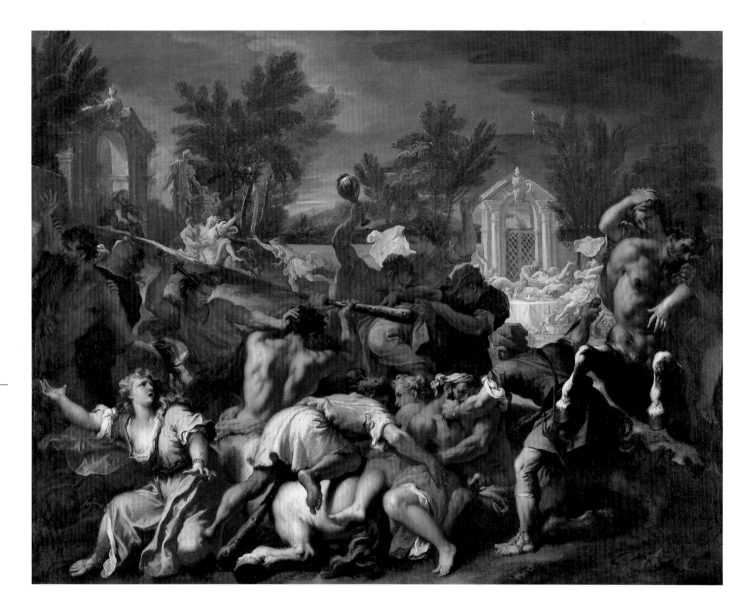

SEBASTIANO RICCI
Italian, 1659-1734

The Battle of the Lapiths and Centaurs, ca. 1705
Oil on canvas, 54½ x 69⅝ inches, gift of the
Samuel H. Kress Foundation, 58.55

Born in Belluno, Sebastiano Ricci studied
in Venice and then worked in Bologna,
Parma, Rome, and Milan before returning
to Venice at the beginning of the eight-
eenth century. He helped to revitalize
Venetian art through his adoption of the
style of the sixteenth-century Venetian
master Paolo Veronese and was one of the
originators of the Venetian Rococo style.

The Battle of the Lapiths and Centaurs
depicts a subject from Ovid's *Metamor-
phoses*. Pirithous, king of the Lapiths,
invited most of the gods, heroes such as
Theseus, and his neighbors the Centaurs
to his wedding with Hippodamia. Spurred
on by Mars, the only god not invited, the
centaur Eurythion drunkenly attempted
to carry off the bride. A furious melee
ensued, in which Pirithous and the other
Lapiths defeated the Centaurs with the
help of Theseus and Hercules. The fluidly
painted landscape background of the
work, where we see Theseus in pursuit
of Eurythion and Hippodamia, contrasts
with the violent action of the intertwined
sculptural figures in the foreground.

GIOVANNI BATTISTA TIEPOLO
Italian, 1696-1770

Matronalia Offering Gifts to Juno Regina, ca. 1745-50

Oil on canvas, 56⅞ x 44⅜ inches, gift of Samuel H. Kress, 32.6

Venetian by birth and training, Giovanni Battista Tiepolo is considered one of the leading masters of the eighteenth century. Although most of Tiepolo's long, prolific career was spent in Venice, the brilliance of his work and the genius of his illusionist ceiling decorations prompted patrons from all over Europe to offer him commissions.

Part of a group of four overdoor panels painted for the Palazzo Barbaro in Venice, Tiepolo's *Matronalia Offering Gifts to Juno Regina* depicts a scene from Livy's *History of Rome.* During the Second Punic War the temple of Juno Regina which stood on the Aventine Hill at Rome was struck by lightning. Livy describes how the city's matrons brought offerings of gifts and jewels from their dowries to the temple to appease Juno, Queen of Heaven, represented here by her distinguishing attribute, the peacock. *Matronalia Offering Gifts to Juno Regina* is a pendant to Tiepolo's *Tarquin and Lucretia*, a famous Roman scene of female virtue and heroism now in Augsburg.

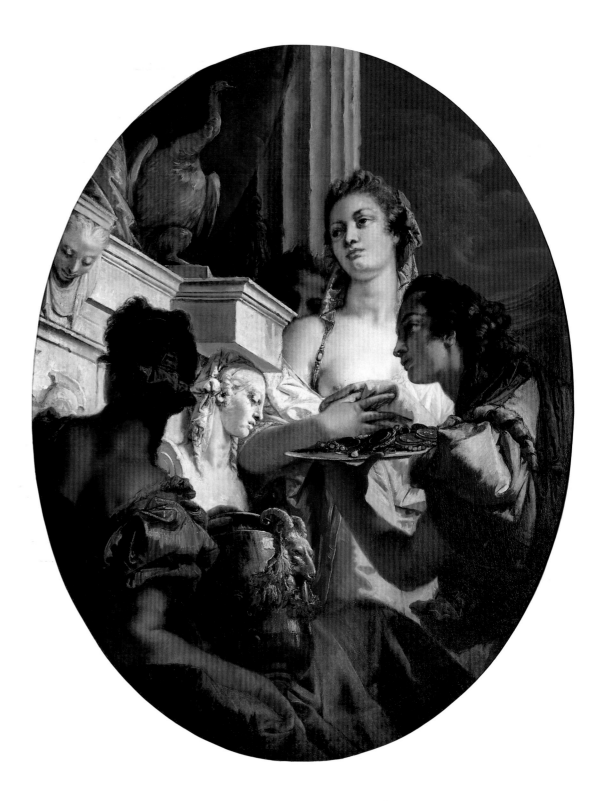

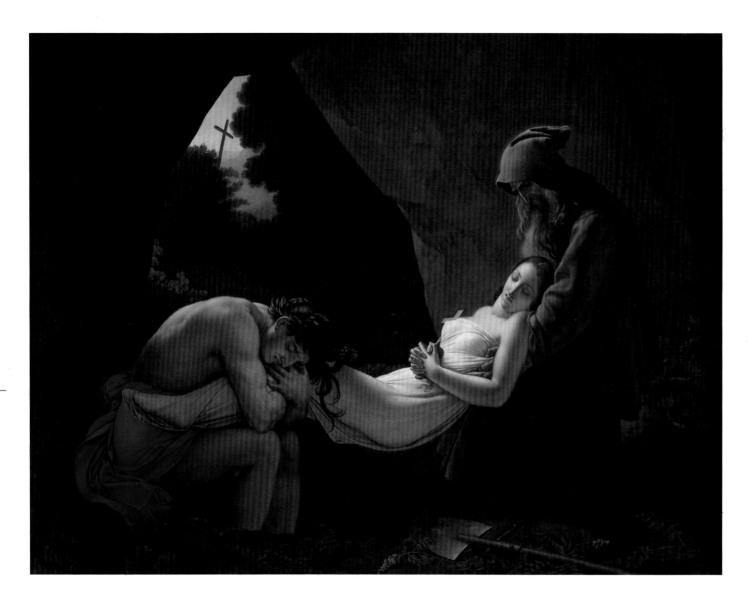

ANNE-LOUIS GIRODET DE ROUCY TRIOSON
CALLED GIRODET-TRIOSON
French, 1767-1824

The Funeral of Atala, ca. 1811
Oil on canvas, 35 x 46³/₈ inches, purchase with funds from the Forward Arts Foundation, 1990.1

Girodet based this painting on Chateaubriand's popular novel *Atala*, published in 1801. The novel recounts the tragic story of Atala, a half-Indian Christian maiden, and Chactas, a Natchez Indian, who fall in love after Atala frees Chactas from captivity. The two flee and seek refuge in a cave. Fearing that she is on the verge of breaking the vow of chastity she made to her dying mother, Atala poisons herself. An early example of French romanticism, the entombment scene portrays the profound grief of the anguished Chactas as he holds his dead beloved. Girodet's idealized handling of the human figures recalls the technique of his teacher, the neoclassical painter Jacques-Louis David.

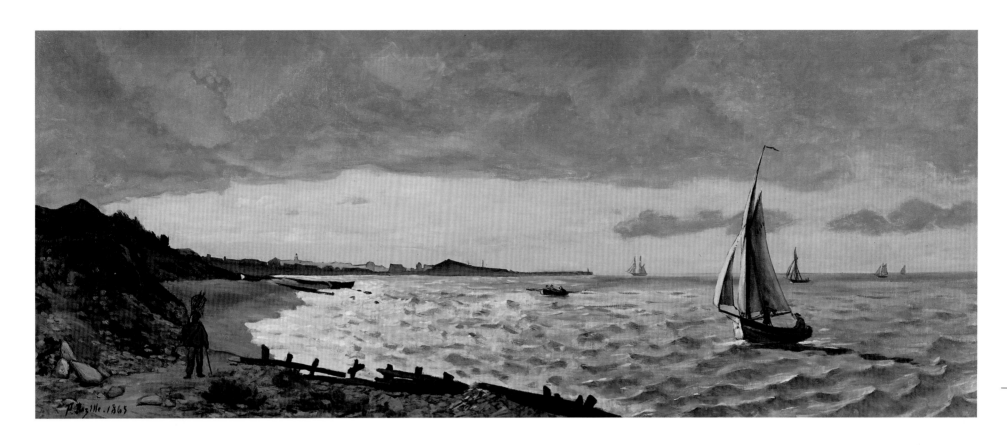

FRÉDÉRIC BAZILLE
French, 1841-1870

Beach at Sainte-Adresse, 1865
Oil on canvas, 23 x 55⅛ inches, gift of the
Forward Arts Foundation in honor of Frances
Floyd Cocke, 1980.62

Frédéric Bazille, one of the original group
of Impressionist painters, was particularly
close to Monet. They traveled together
and shared a studio in Paris. *Beach at
Sainte-Adresse* was one of a pair of paint-
ings commissioned from the artist by his
uncle. Its unusual horizontal format was
dictated by its intended use as an overdoor
painting. The work depicts the beach near
Monet's home at Honfleur and is similar
to a painting of the site executed by
Monet in 1864. Bazille's career in the van-
guard of Impressionism was cut short by
his death in the Franco-Prussian War.

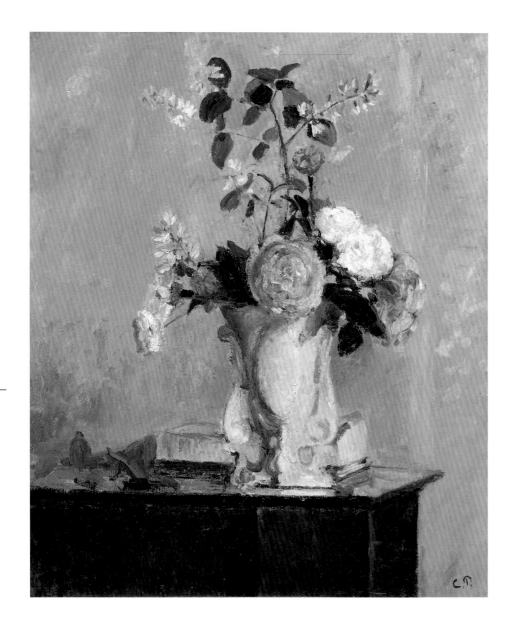

CAMILLE PISSARRO
French, 1830-1903

Bouquet of Flowers, ca. 1873
Oil on canvas, 21⅝ x 18¼ inches, gift of the
Forward Arts Foundation in honor of its first
president, Mrs. Robert W. Chambers, 74.231

A central figure in the Impressionist cir-
cle, Camille Pissarro arrived in Paris in
1855 where he met and befriended Monet.
He was also influenced by Corot and
Courbet and worked frequently with
Cézanne, introducing him to Impression-
ism. Specializing mostly in landscapes,
Pissarro also painted still lifes like this
Bouquet of Flowers. Pissarro's arrange-
ment of peonies, his wife's favorite flower,
and lilies drew inspiration from his wife's
beautiful garden, from which she often
gathered bouquets for his still lifes.

C. F. DAUBIGNY
French, 1817-1878

Banks of the Oise River, 1875
Oil on canvas, 24 x 39½ inches, purchase
with a bequest of Lenora Raines and general
funds in honor of the 20th anniversary of the
Forward Arts Foundation, 1985.21

During the last few years of his life,
Charles-François Daubigny traveled the
rivers of France on his boat, observing and
painting the French countryside. He prob-
ably finished his paintings more com-
pletely in the out-of-doors than did many
other artists, who tended to work up their
compositions in the studio. Daubigny can
be seen as a link between the Barbizon
painters, who were among the first to
paint nature on the spot, and the Impres-
sionists of the next generation, who strove
to capture fleeting impressions of light
and atmosphere.

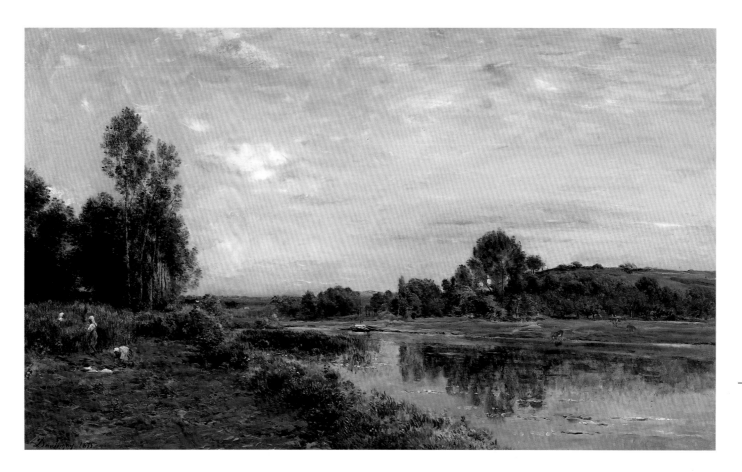

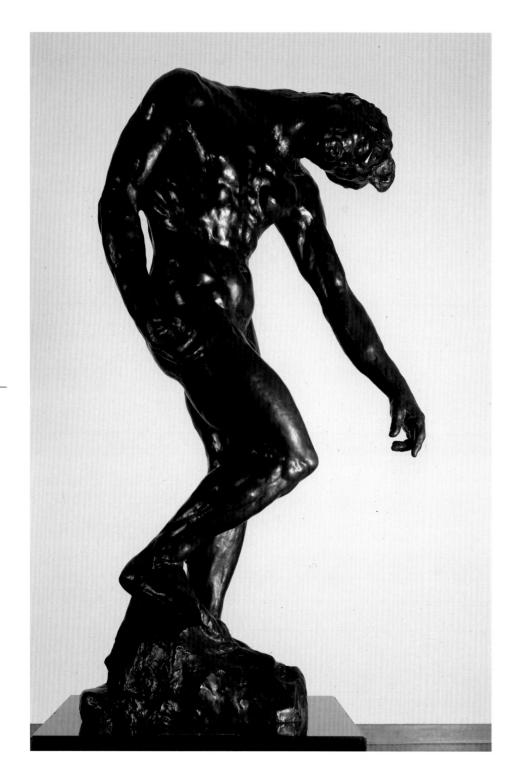

AUGUSTE RODIN
French, 1840-1917

The Shade, 1880
Bronze, 1968 cast, 75¼ x 44⅛ x 19¾ inches, gift of the French Government to the Atlanta Arts Alliance, 1968, EL78.1983

In 1880, Rodin, often considered the greatest French sculptor of the nineteenth century, accepted a commission from the French government for a set of monumental gates for a proposed museum of decorative arts. Although the museum was never constructed and Rodin's *Gates of Hell* were not cast until after his death, several of Rodin's greatest and most famous works were extracted from this commission.

The *Gates* were inspired by the literary works of Dante and Baudelaire and artistic masterpieces like Michelangelo's Sistine Chapel. *The Shade* is an enlarged version of one of three muscular male figures that, locked together, surmount the grand portal. The three figures represent spirits of the departed confronted by Dante and Virgil in *The Inferno*. The figure's apparent angst and defeated posture recall the inscription on the Gates of Hell: "Abandon Every Hope, all ye who enter Here."

CLAUDE MONET
French, 1840-1926

Houses of Parliament in the Fog,
1903
Oil on canvas, 32 x 36³/₈ inches, purchase
with Great Painting Fund in honor of Sarah
Belle Broadnax Hansell, 1960.5

Monet continued to record fleeting effects
of light and atmosphere long after many
of his fellow Impressionists had aban-
doned the practice. Around 1890, he began
to paint multiple versions of the same
motif, lining up as many as one hundred
canvases and moving from one to another
as the light changed. At the turn of the
century, Monet worked in London, where
he painted a series of the Houses of Parlia-
ment from a balcony of Saint Thomas's
Hospital directly across the Thames.

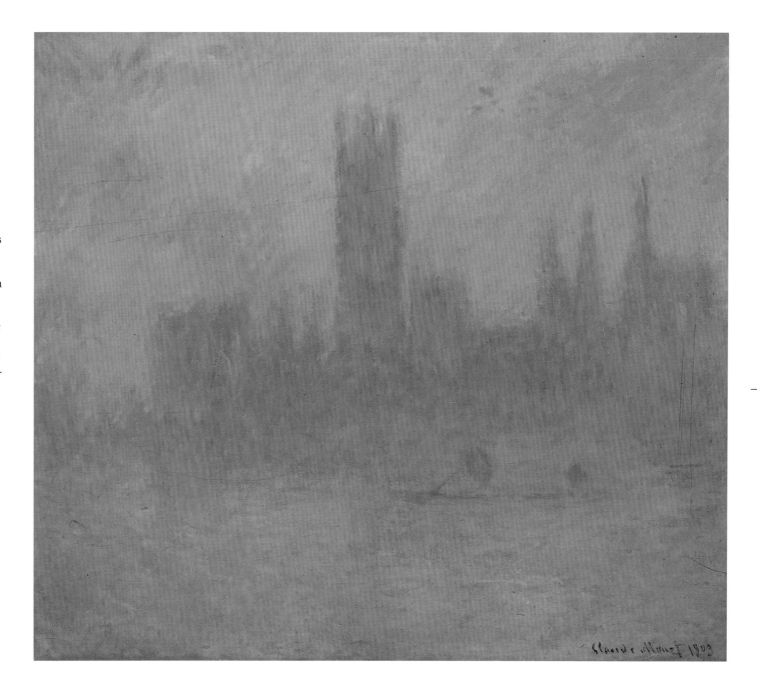

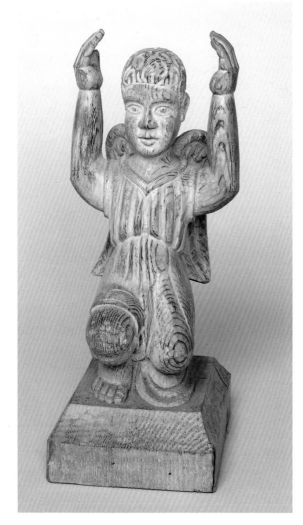

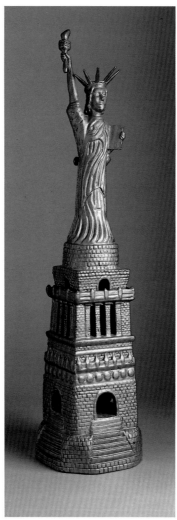

UNIDENTIFIED ARTIST
American, 19th century

Angel, ca. 1875-1925
Yellow pine, 26¼ x 11¼ x 11¼ inches,
purchase, 1993.114

Carved in native southern yellow pine,
this figure is believed to have been an
ornament in a yet-to-be-identified Afri-
can-American church in Alabama located
between Anniston and Birmingham. The
angel is depicted as a young African or
African-American boy. The pose and scale
of the figure relate it to late nineteenth-
century American cemetery sculpture. It
may have been inspired by small monu-
ments, often executed in marble or stone,
memorializing children. Such examples
survive in rural and urban cemeteries
throughout the South.

ULYSSES DAVIS
American, 1914-1991

Statue of Liberty, 1939
Gold-painted cypress, 25 x 5½ x 5½ inches,
purchase with funds from the Decorative
Arts Acquisition Trust and the 20th Century
Art Society, 1986.82

Ulysses Davis was a self-trained barber
and sculptor, who worked in Savannah,
Georgia. He began his trade and his art as
a child in his birthplace, Fitzgerald, in
rural south-central Georgia. After the
tenth grade Davis quit school to help sup-
port his family. He was an office worker
for the railroad, then constructing a line
through Fitzgerald. The *Statue of Liberty*
was carved from a cypress railroad tie
when Davis was 25.

Davis moved with the railroad to Savan-
nah in 1942, continuing to carve in his
spare time. Idled by a layoff in the early
1950s, Davis opened a barber shop behind
his home. His shop became a neighbor-
hood social center, where he exhibited the
sculptures he continued to execute for the
remainder of his life.

Davis's favorite subjects were religious
and patriotic themes and fantastic crea-
tures of his own imagination, often based
on combinations of human and animal
forms. In both the architectural decora-
tion of his shop and his sculptures, Davis
used metal die stamps that he made from
automobile bushings.

BILL TRAYLOR
American, 1854-1947

Man and Woman, undated
Tempera, pencil, and colored pencil on cardboard, 13⅞ x 11⅛ inches, purchase with funds from Mrs. Lindsey Hopkins, Jr., Edith G. and Philip A. Rhodes, and the Members Guild, 1982.97

Bill Traylor was born into slavery on an Alabama plantation, where he lived until 1938, when he moved to Montgomery. Homeless, he wandered the city's Monroe Street by day and slept in the back room of a funeral parlor at night. To earn money for food, he sold drawings he made on whatever scraps of paper or cardboard he could find. Traylor drew simple, geometric shapes that he filled with color and elaborated into human or animal figures. The strength of his work lies in his ability to abstract, simplify, and combine objects, and in his skill as a visual storyteller. This drawing is one of thirty in the collection of the High Museum of Art.

HOWARD FINSTER
American, born 1916

Waste Can, ca. 1979
Enamel on metal, 29⅞ x 19 x 19 inches, gift of Andy Nasisse for the Nasisse Collection, 1993.95

The Reverend Howard Finster grew up on a farm in Alabama and experienced his first vision when he was three. At sixteen he committed himself to preaching the word of God; in adulthood, he served as pastor of nine churches in Alabama and Georgia. In the mid-1970s a vision instructed him to "paint sacred art." Inspired by his religious visions, Finster uses found materials and fills his works with portraits of patriots, celebrities, and biblical characters, and scriptural quotations and evangelical messages.

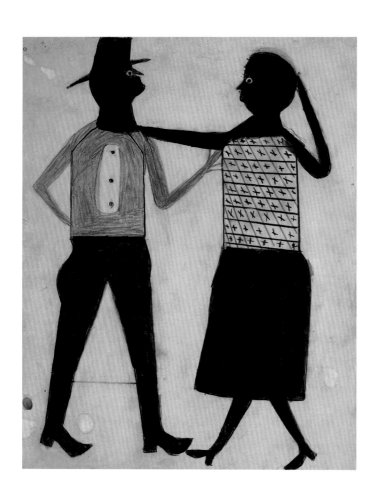

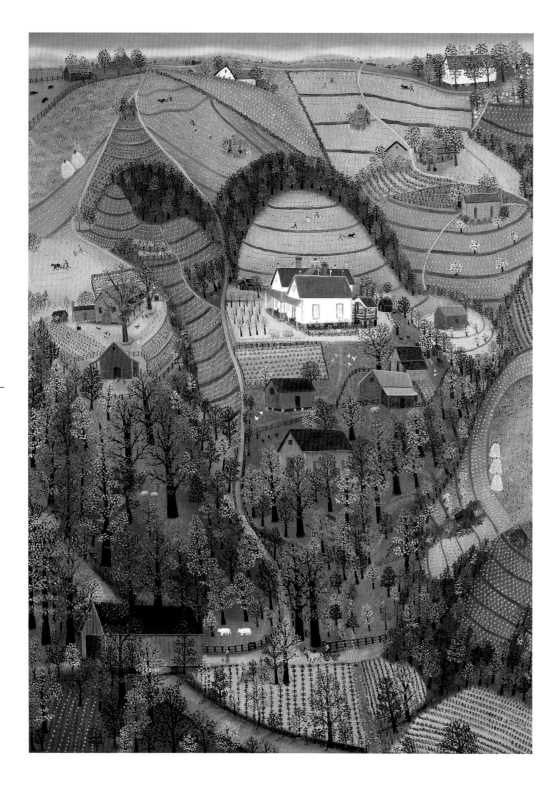

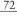

MATTIE LOU O'KELLEY
American, born 1908

My Parents' Farm, 1980

Oil on canvas, 58 x 42 inches, gift of the
artist in memory of her parents, Mary Bell
Cox O'Kelley and Augustus Franklin
O'Kelley, and their children, Willie, Lillie,
Gertrude, Ruth, Tom, Ben, Mattie Lou and
Johnnie, 1980.68

Mattie Lou O'Kelley grew up on a hill
farm in Banks County, Georgia. This rural
background is the inspiration for her
paintings, which evoke a land of child-
hood long ago. Her themes—family, home,
harvest, birth, death, and simple pleasures
of rural life—are painted from her imagina-
tion-embellished memories.

THORNTON DIAL
American, born 1928

Struggling Tiger Know His Way Out, 1991

Enamel on braided rug, tin, sealing compound, and plywood on canvas, 65$^{1}/_{2}$ x 88 x 3$^{1}/_{2}$ inches, gift of William Arnett through the 20th Century Art Acquisition Fund, 1992.51

A self-taught artist, Thornton Dial incorporates discarded materials such as cut tin, carpet remnants, rope, and glass shards into the surfaces of his built-up, three-dimensional canvases. He has said of his work: "Art ain't about paint. It ain't about canvas. It's about ideas. Too many people died without ever getting their mind out into the world. I have found out how to get my ideas out and I won't stop. I got ten thousand left."

The tiger appears repeatedly in Dial's often autobiographical narrative works. In his "Struggling Tiger" series, Dial explores the choices facing Black men. In this final painting of the series, the tiger emerges from a blazing environment tangled with images–including a woman's face, nesting birds, and a fruit tree.

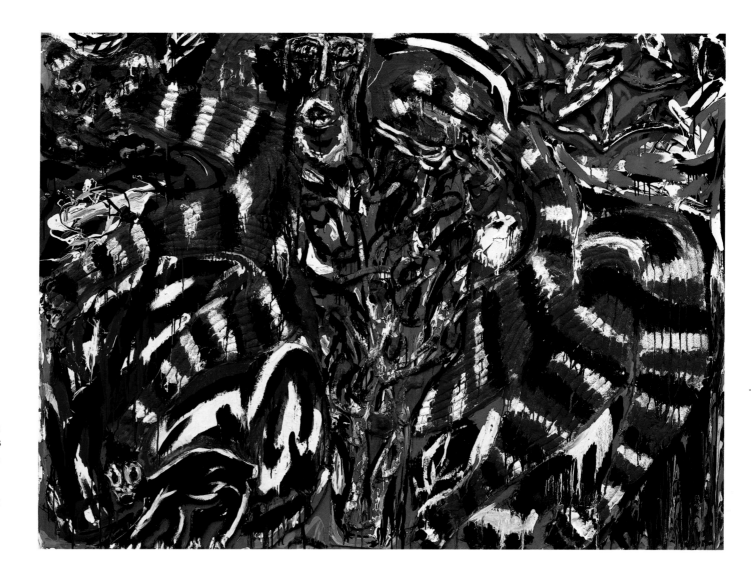

74

MAX ERNST
French, born in Germany, 1891-1976

Tree of Life, 1928
Oil on canvas, 114¼ x 82¾ inches, purchase
with funds from Alfred Austell Thornton
in memory of Leila Austell Thornton and
Albert Edward Thornton, Sr., and Sarah
Miller Venable and William Hoyt Venable,
1983.92

In *Tree of Life*, Max Ernst depicted a
dream-like underwater world inhabited by
strange hybrid creatures. Like his fellow
surrealists, Ernst challenged traditional
artistic values by tapping the irrational,
inner world of dreams and the sub-
conscious: he wanted to exploit "the
chance meeting of two remote realities
on a plane unsuitable to them." To do so,
he used unsettling juxtapositions of unre-
lated objects and invented improvisational
methods of painting, such as *frottage*
(rubbings of texture) and *grattage* (scrap-
ing the surface of the canvas). He used
both techniques in *Tree of Life* to produce
unexpected images.

 "It is the time when the forest takes
wing and flowers struggle under
water. . . . It is the time of the circum-
flex medusa," Ernst said. *Tree of Life*
epitomizes this other-world; its dominant
creature has a bird's head and the body of a
serpent. From early childhood, Ernst was
obsessed with birds and often included
them in his paintings. Just as birds were
symbols of pleasure for the artist, snakes
were symbols of horror. The central, black
biomorphic form is actually a sea snail,
which may also symbolize the Tree of
Life. It seems to evolve from an aqueous
world inhabited by crabs and the circum-
flex medusa, a type of jellyfish named
after the horrific mythological character
with snakes for hair.

ARSHILE GORKY
American, born in Armenia,
1905-1948

Garden in Sochi, 1940-41

Gouache on board, 21 x 27³/₄ inches, purchase
with bequest of C. Donald Belcher, 1977.50

In *Garden in Sochi*, Arshile Gorky drew
upon his childhood memories of Armenia
and an abstract, biomorphic language
inspired by the works of the Spanish artist
Joan Miró. Inspired by the surrealists'
emphasis on subjects drawn from dreams
and the subconscious, Gorky conveyed
his remembrances of villagers visiting his
father's garden:

> This garden was identified as the Gar-
> den of Wish Fulfillment. . . . Above all
> stood an enormous tree all bleached
> under the rain, the cold, and deprived
> of leaves. This was the Holy Tree. . . .
> I had witnessed many people, whoever
> did pass by, that would tear voluntarily
> a strip of their clothes and attach this
> to the tree.

On the left, Gorky indicated the gar-
den's magic blue rock; in the upper right
corner is a trace of the fluttering strips
of cloth the villagers attached to the
garden's big poplar tree (an Armenian
custom). According to Gorky, the central
image was inspired by an old-fashioned
butter churn.

75

JACOB LAWRENCE
American, born 1917

Marionettes, 1952
Tempera on gesso panel, 18¼ x 24½ inches,
purchase with funds from the National
Endowment for the Arts and Edith G. and
Philip A. Rhodes, 1980.224

Marionettes is one of a series of pictures
inspired by Harlem theaters, particularly
the Apollo, where Jacob Lawrence often
went in his youth during the Depression.
In these works–painted after the artist's
mental breakdown and psychiatric hospi-
talization–role-playing and manipulation
of others are recurrent themes.

 Marionettes is one of Lawrence's more
abstract works. It reflects the influence of
cubism and African art on his work, as
seen in the mask-like faces of the tangled
puppets. Lawrence gained early critical
attention during the late 1930s for his
straightforward narrative series on themes
of Black life and history.

JOSEPH CORNELL
American, 1903-1972

Ludwig II of Bavaria, ca. 1953
Paper, photomechanical reproduction, ink and colored pencil on tempera on stained wood, glass, 16½ x 11 x 4 inches

Cassiopeia, ca. 1957
Photomechanical reproduction on tempera on stained wood, clay, cork, metal, glass, 9⅝ x 15⅛ x 3 inches, gifts of the Joseph and Robert Cornell Memorial Foundation, 1993.156 and 1993.157

Joseph Cornell was largely self-taught as an artist. By the time he graduated from high school, Cornell had begun a life-long habit of collecting ephemera–ballet programs, magazine illustrations, foreign-language publications, knick-knacks bought at dime stores or found on the street.

In 1931, Cornell saw an exhibition of Max Ernst's collage-novel *La femme 100 têtes* at Julien Levy's Manhattan gallery and began assembling his collected materials into collages. The following year, Levy presented a group show of surrealist luminaries that included works by Ernst, Dali, and Man Ray, all of whom were present at the opening. Cornell attended the preview and, despite his shyness, managed to introduce himself to these artists, who quickly accepted him as a kindred spirit. Although influenced by their methods and ideas, Cornell was never as acerbic or ironic as the surrealists. Instead, his art evokes quiet nostalgia, and reverie rather than delirium. A gentle and reclusive man, he was content to travel the world–an imaginative, whimsical, romantic world of his own making–via his art.

Cornell was extremely fond of ballet: dancers appear frequently in his works. He was also something of a star gazer, equally interested in constellations and celebrities. Thus, glossy images of starlets torn from fanzines appear in many of his collages. He also often incorporated astronomical charts into his work and was particularly intrigued by the constellations Andromeda and Cassiopeia. The white clay pipes that frequently appear in his boxes recall Cornell's Dutch heritage, of which he was quite proud.

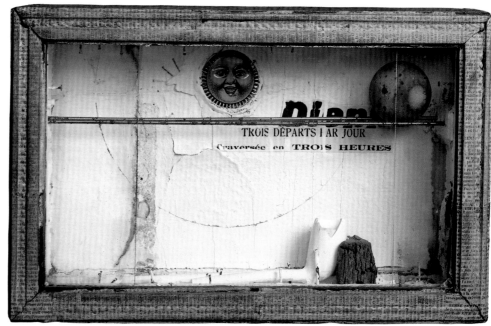

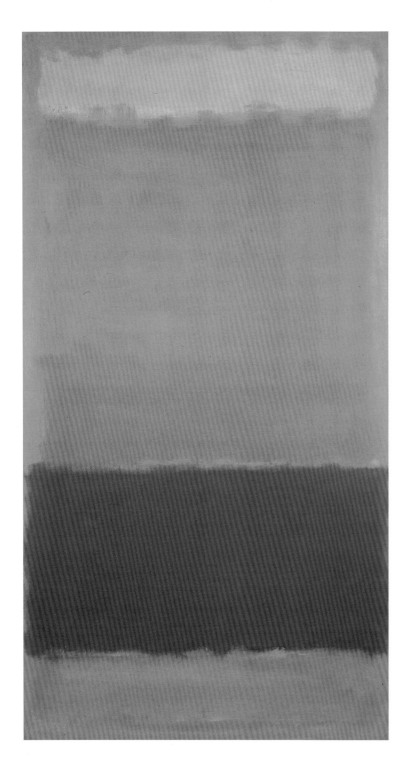

MARK ROTHKO
American, 1903-1970

Number 73, 1952
Oil on canvas, 55³/₈ x 30³/₈ inches, gift of
The Mark Rothko Foundation, Inc., 1985.27

For the abstract expressionists, primitive
art and mythology offered universal
subjects, and surrealism suggested new
ways of generating images. From these
roots, Mark Rothko developed his desire
to express "basic human emotions–
tragedy, ecstacy, doom." In order to reveal
the unconscious through archetypal
images, Rothko used the surrealist tech-
nique of automatism, letting images
reveal themselves spontaneously as his
hand wandered across the canvas or paper.
 Rothko eventually abandoned the use
of specific images, which he saw as too
limited and finite and evolved his signa-
ture style of glowing and hovering fields
of color. Developed fully by 1949, Rothko's
expansive use of color was an inspiration
to color-field painters of the 1960s, who
were interested in pure color and form.

PHILIP GUSTON
American, 1913-1980

Painter, 1959

Oil on canvas, 65 x 69 inches, purchase with funds from the National Endowment for the Arts, 74.118

A "gestural" abstract expressionist during the 1950s and 1960s, Philip Guston saw his large canvases as arenas in which to act, and as records of spontaneous gestures. Many of Guston's abstractions have representational associations, however, such as in *Painter*. (Both Guston's early and late works are highly representational.)

Here, an imposing, central black form seems to imply both an easel and a figure in motion: the title suggests that this animated body is the artist, involved in passionate, improvisational painting. The figure–composed of rapid brush-strokes–exemplifies the words of Harold Rosenberg, a critic close to the abstract expressionists: "A painting that is an act is inseparable from the biography of the artist. . . . The new painting has broken down every distinction between art and life."

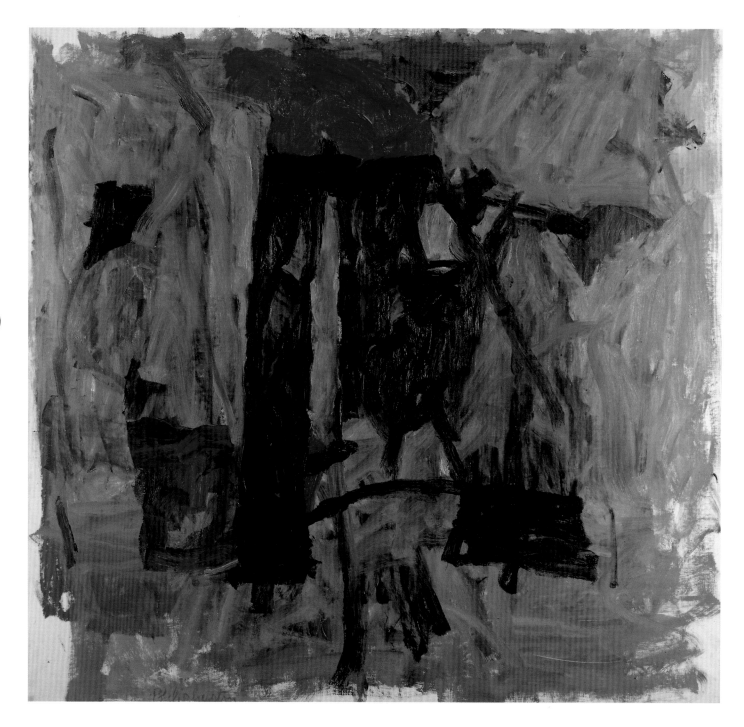

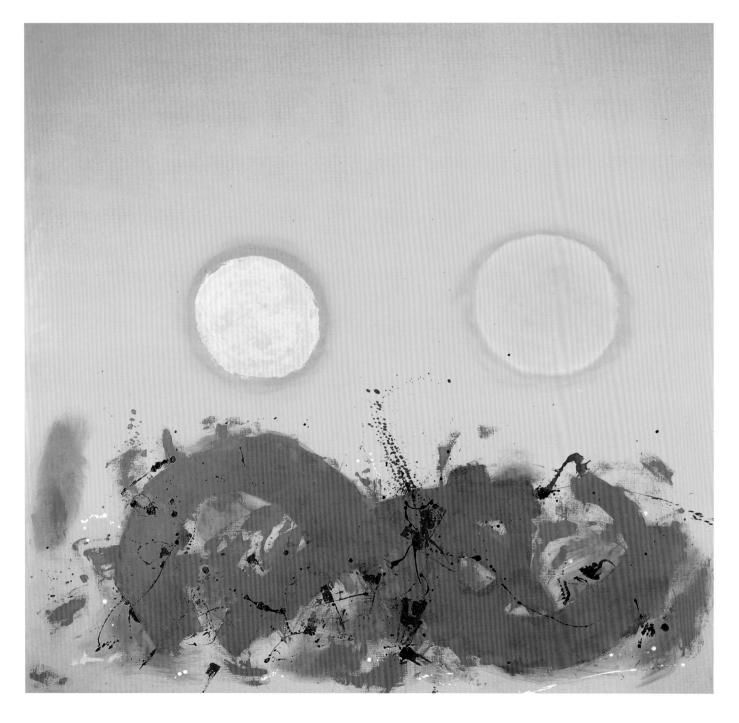

ADOLPH GOTTLIEB
American, 1903-1974

Duet, 1962
Oil on canvas, 84 x 90 inches, gift of Nelson
A. Rockefeller, 63.2

For Adolph Gottlieb and other abstract
expressionists, myth played an important
role in their works of the late 1930s and
early 1940s. These artists were searching
for symbols to express universal emotions
and seeking more powerful statements
than social realism's depictions of objects
or the formal exercises of geometric
abstraction. Although many gradually dis-
carded primitivistic or mythic imagery,
Gottlieb developed and sustained his use
of such symbols, as seen in this painting.

Duet is from Gottlieb's "Bursts" series,
paintings that occupied the artist from
1957 until his death. Although Gottlieb's
signature motifs are often strongly sugges-
tive of landscape elements, he intended
his images to evoke general themes,
dualities, and the conflict of opposites.
He combined the gestural–the record of
process, as in Jackson Pollock and Willem
de Kooning–with a concern for color char-
acteristic of the paintings of Mark Rothko
and Barnett Newman.

ROBERT RAUSCHENBERG
American, born 1925

Overcast III, 1963

Oil on canvas, silkscreen on Plexiglas,
71 x 105 x 11 inches, purchase with funds
from Alfred Austell Thornton in memory of
Leila Austell Thornton and Albert Edward
Thornton, Sr., and Sarah Miller Venable and
William Hoyt Venable, 1986.141

Robert Rauschenberg conveys the simul-
taneity and multiplicity of events in our
media-saturated world with his dense
profusion of images. During 1962-64,
Rauschenberg frequently used photo
silkscreens made from reproductions in
newspapers and magazines. The interplay
of such images in works like *Overcast III*
evokes the rapid, interwoven barrage
of information typical of the age of
mass media.

 Many of these images refer to events of
the early 1960s and reflect Rauschenberg's
enthusiasm for space exploration–then
seen as the new American frontier.
Specific references include clouds, the
launch of the spacecraft Sigma 7, and a
huge radio transmitter/receiver. His
images spark a host of other associations
–such as, for example, the four elements:
earth, air, fire, and water.

 Rauschenberg adopted the gestural
technique and heroic scale of abstract
expressionism but rejected abstract paint-
ing as too removed from everyday life. By
incorporating popular images into his art
and by using commercial techniques,
Rauschenberg prefigured the widespread
use of commercial imagery and references
in pop art of the later 1960s.

82

Manteneia I, 1968
Acrylic on canvas, 60 x 240 inches, gift of
Frances Floyd Cocke, 78.56

Although other artists had departed from
the traditional rectangular support for
their paintings, Frank Stella was the first
to explore the shaped canvas; his canvas's
irregular format coincides with the pattern painted on it. *Manteneia I* is part of
a long series of works based on semi-circular motifs, known as the "Protractor
Series." Possibly inspired by patterns in
medieval Irish manuscripts, the interwoven bands of fluorescent hues create
spatial discontinuities since none of the
arcs lies in consistent relationship with
the others.

Stella strives for an immediate, purely
visual effect: "All I want anyone to get out
of my paintings . . . is that you can see the
whole idea without confusion. . . . What
you see is what you see."

JACKIE WINSOR
American, born 1941

Double Bound Circle, 1971
Hemp, 16 x 61 inches in diameter, purchase
with funds from the Members Guild and the
National Endowment for the Arts, 1980.95

Jackie Winsor's laboriously handcrafted
sculpture contrasts with the impersonal,
often machine-made works of most mini-
malist sculptors. Like the minimalists,
she employs simple geometric forms.
Her work, however, is unusual in her
preoccupation with a hands-on working
process, materials such as rope, and
naturalistic references: "What interested
me about . . . the rope was that it so stub-
bornly had its own personality. It really
persisted in identifying itself. Its weight
and heaviness and, as you pulled it out,
its linear quality. Its personality was so
strong that I wanted to bring part of
me to *it*."

 Double Bound Circle's simple form
holds in check its muscular strength
and complexity and gives a sense of self-
containment. Speaking of her rope pieces,
Winsor observed: "You relate to them the
way you might relate to a sleeping person,
to the potential energy that is manifested
in a dormant state."

ELIZABETH MURRAY
American, born 1940

Brush's Shadow, 1981
Oil on canvas, 116 x 86½ inches, gift of
Frances Floyd Cocke, 1981.54

Elizabeth Murray has reinvigorated con-
temporary abstract painting by infusing
her work with autobiographical references
and allusions to domestic life. Her
vaguely recognizable forms are usually
derived from everyday objects such as
tables, shoes, and coffee cups. *Brush's
Shadow* is in fact a kind of self-portrait.
The central green shape represents a brush
("the tool I use to communicate with");
the shape behind it (the "brush's shadow")
is a figure, a stand-in for the artist herself.
Her art is thus her public face, as she
works diligently in its shadow.

A native midwesterner, Murray moved
to New York in 1967. The art world was
then dominated by the impersonal, aus-
tere geometry of minimalist sculpture. At
a time when painting was largely consid-
ered "dead," Murray developed an eccen-
tric and energetic style for which she
finally received widespread recognition in
the early 1980s. Her unlikely subjects and
emphasis on personal experience have
expanded and perhaps feminized the
vocabulary of historical modernism. She
has said, "I want my paintings to be like
wild things that just burst out of the zoo."

FAITH RINGGOLD
American, born 1930

Church Picnic Story Quilt, 1988
Tie-dyed, printed fabrics, acrylic on cotton
canvas, 74½ x 75½ inches, gift of Don and
Jill Childress through the 20th Century Art
Acquisition Fund, 1988.28

Faith Ringgold tells the often bittersweet
history of daily life in Black America
from a personal and feminist perspective.
Fabrics and other domestic craft materials
figure prominently in her art. Since 1983,
she has combined the traditions of story-
telling and quilt-making in her painted
"story quilts," which began as collabora-
tions with her mother, Willi Posey, a
well-known designer and seamstress in
Harlem. Ringgold fondly remembers
watching her grandmother quilt; for her,
this intergenerational activity reflects
shared female ties and the strong familial
bonds of African-Americans.

 Church Picnic Story Quilt was com-
missioned for the High Museum of Art.
The story is set in Atlanta's Piedmont
Park in 1909, a year of unprecedented
growth in the city and, in the artist's
mind, a time of optimism and of renewed
community for southern Blacks. The
details of the day's festivities are
recounted by Mama, seated in the upper
right-hand corner, whose young son
gently touches her on the shoulder.
The Reverend Stillwood and Miss Molly
Mason embrace, as clusters of family and
friends look on. Mama's account, told to
her daughter Aleathia, who was absent
from the picnic, reveals the web of com-
plex relationships among characters pic-
tured in the quilt, and exposes Aleathia's
unrequited love for the Reverend.

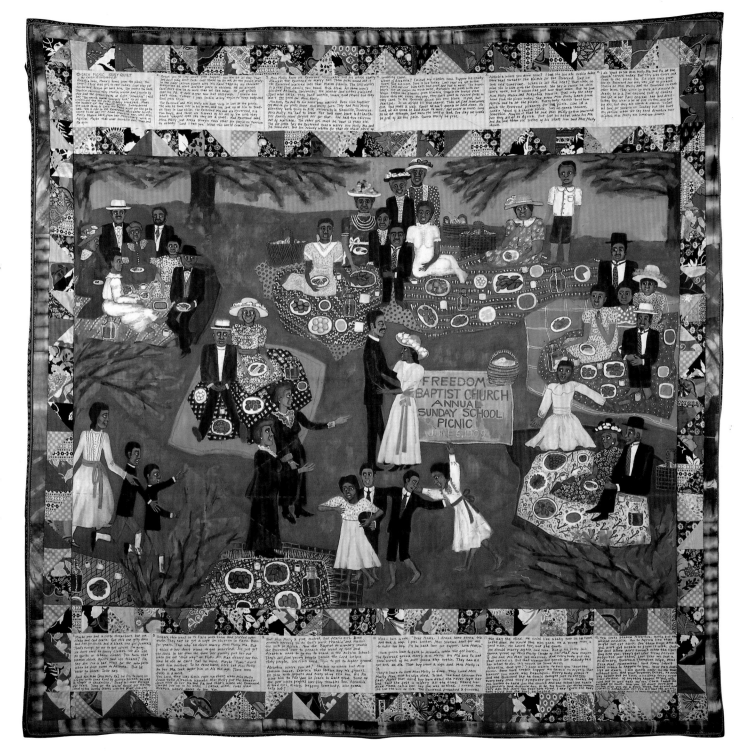

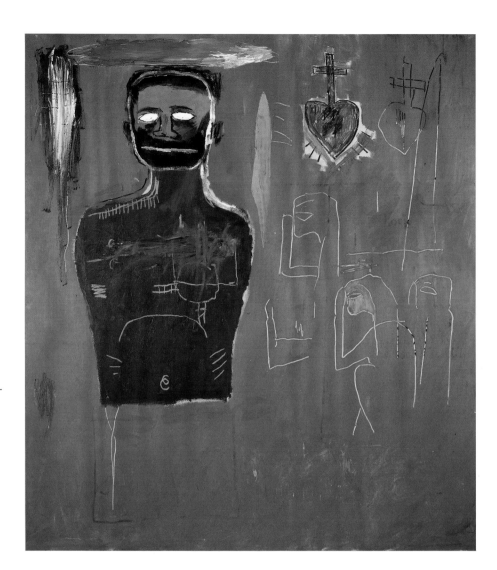

JEAN-MICHEL BASQUIAT
American, 1960-1988

Untitled (Cadmium), 1984

Oil, oil stick, and acrylic on canvas, 66 x 60 inches, purchase in honor of Lynne Browne, President of the Members Guild, 1992-93, with funds from Alfred Austell Thornton in memory of Leila Austell Thornton and Albert Edward Thornton, Sr., and Sarah Miller Venable and William Hoyt Venable, 1993.3

Jean-Michel Basquiat was one of the most productive and accomplished artists to emerge from the vibrant East Village art scene of the early 1980s. Given to self-mythologizing, Basquiat often claimed to be a Haitian-born child of the ghetto; he was, in fact, solidly middle-class, born and raised in Brooklyn. Basquiat's early interest in art was encouraged by his parents, who took him to museums in Brooklyn and Manhattan.

Soon after Basquiat was expelled from school in the eleventh grade, he and his friend Al Diaz began to "bomb" lower Manhattan. They concentrated spray-painted graffiti around Soho and downtown clubs, and became friends with other young graffiti artists like Keith Haring, Kenny Scharf, and Fred Brathwaite. In 1980 Basquiat's art appeared in *The Times Square Show*, a seminal exhibition of work by East Village artists, and his work soon attracted the attention of dealers and collectors. In 1983, Basquiat was befriended by Andy Warhol, his long-time idol.

Basquiat consistently explored themes of oppression and conflict. He mockingly depicted racial stereotypes with thickly painted, totemic images that are both savage and sophisticated. According to the artist Joe Lewis, this painting is reminiscent of Matisse's *Red Room* in its unpretentious pictorial hedonism. . . . The work is alive with a simple unrestricted aloofness also found in the older master's interiors. But Basquiat adds another dimension. First there is a touch of troubling subject matter–a Sacred Heart and an armless haloed figure with what seem like stitches seaming his neck. Calligraphic ornament (an Oriental device closely associated with Matisse) is incorporated in a series of outlined female forms, suggesting Egyptian mourning figures. The formal simplicity of Basquiat's paintings represents his thorough command and fluent use of the history of painting, rather than . . . stumbling "wolf-boy" élan.[1]

1. Joe Lewis, "Appreciation: Basquiat," *Contemporanea* 2, no. 5 (July/August 1989):82.

ALISON SAAR
American, born 1956

Tobacco Demon, 1993

Ceiling tin, shellac on wood, found objects,
78¼ x 25¼ x 14 inches, purchased through
funds provided by AT&T NEW ART/NEW
VISIONS and 20th Century Art Acquisition
Fund, 1993.17

As an apprentice in her father's restoration
studio, Allison Saar gained first-hand
knowledge of ancient Chinese, African,
Egyptian, and pre-Columbian objects. Her
art reflects her assimilation of these varied
sources and her longstanding interest in
the traditions of folk and outsider art.

In *Fertile Ground*, an installation
created in 1993 for the High Museum of
Art, Saar addressed the rich yet disturbing
agricultural history of the South. Through
five powerful totemic figures, the artist
investigated the southern landscape
through the eyes of African-Americans,
for whom it carries a complex legacy of
nurture, repression, and cultural survival.
Three nurturing allegorial female spirits
watched over *Fertile Ground*. The positive
forces represented by these figures were
countered by two "agridemons" represent-
ing the continual depletion of the soil and
the painful separation of families. *Tobacco
Demon* is based on the character of Baron
Samedi of Haitian *voudoun* folklore,
thought to be connected with the ritual-
istic use of neurotoxins in the creation
of zombies. He is the exploitative deal-
maker who profits from the labors and
sufferings of others; here, as the overseer,
he also makes reference to modern-day
drug lords. Dressed in a tobacco-leaf suit,
he appears as sticky as the resins of the
tobacco plant.

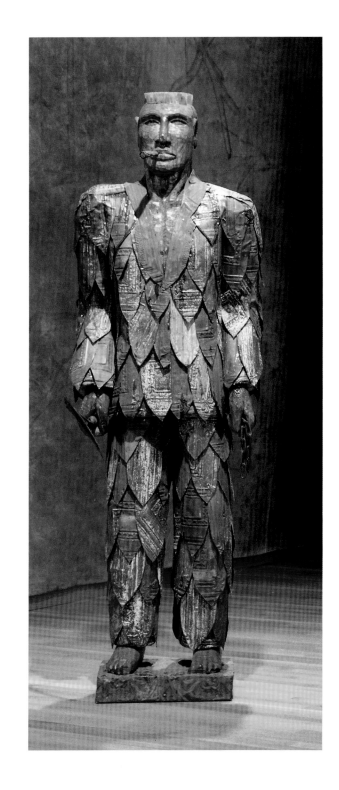

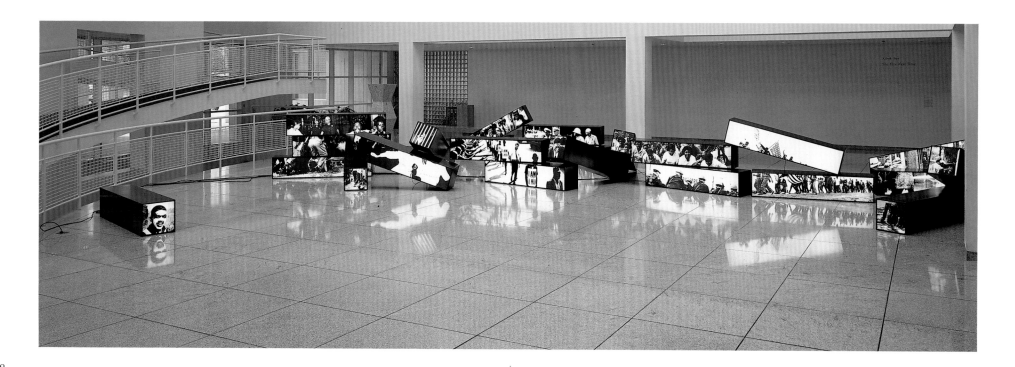

ALFREDO JAAR
Chilean, born 1956

The Fire Next Time, 1989
Twenty-two metal light boxes with black and white transparencies, each 18 x 18 x 72 inches, overall dimensions variable, purchase with funds from the National Endowment for the Arts, the 20th Century Art Acquisition Fund, and funds from Alfred Austell Thornton in memory of Leila Austell Thornton and Albert Edward Thornton, Sr., and Sarah Miller Venable and William Hoyt Venable, 1989.51

If we do not now dare everything, the fulfillment of that prophecy, recreated from the Bible in song by a slave, is upon us: *God gave Noah the rainbow sign, no more water; the fire next time!*

James Baldwin
The Fire Next Time, 1962

When Alfredo Jaar came to New York from his native Chile in 1981, he was shocked at the pervasiveness of racial inequality in the United States, despite the headway made by the Civil Rights Movement. Jaar addresses these troubling issues in *The Fire Next Time*.

Jaar used stark newspaper photographs of demonstrations of the 1960s to create a dynamic and poignant view of the civil rights struggle. Some of these pictures are readily recognizable, such as the image of firefighters blasting demonstrators with high-powered fire hoses during the Birmingham freedom marches of May 1963.

The chaotic stacking of the light boxes that hold these images reflects, for the artist, the violence, disorientation, and turbulence of the 1960s. The precarious balance of the boxes–roughly the size of a person, or a coffin–is also a metaphor for the tense uneasiness of race relations today.

Jaar initially studied film and architecture. Here, he mixes long-shots and cropped close-ups in a fashion that recalls the jump cuts of television news and film. One must move around and through *The Fire Next Time* to view it, and thus become surrounded by these powerful and haunting images. Jaar's light boxes also refer to the clean geometric forms and industrial materials of minimalist art, which emerged concurrently with the Civil Rights Movement. Whereas minimalist sculpture was impersonal and aloof, Jaar charges his art with political and emotional meaning.

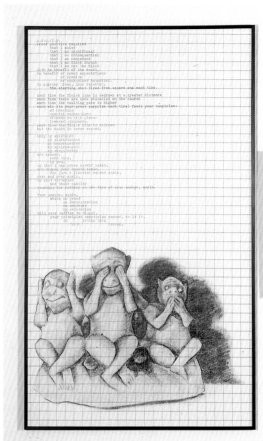

ADRIAN PIPER
American, born 1948

Decide Who You Are #26:
Q.E.D./I.D., 1992
Photo screenprints on paper, four parts, two
72 x 42 inches, two 25½ x 36 inches, pur-
chase with funds from the 20th Century Art
Acquisition Fund, 1992.377

In an attempt to confront pervasive and
negative stereotypes, Adrian Piper
explores issues of gender, race, and sexu-
ality in her art. In each of the works in her
series *Decide Who You Are,* a picture of
Anita Hill at age eight (an archetypal
image of innocence and vulnerability for
the artist) is superimposed on text that
evokes the voice of a "benevolent censor"
(who is, presumably, white and male). On
each of the left-hand panels is a drawing
of the three monkeys who hear no evil,
see no evil, and speak no evil–symboliz-
ing social irresponsibility, negligence, and
denial. The text on each of the left-hand
panels is poignant and poetic–a personal
reaction to the patronizing attitude of the
text on the opposite panel.

Decide Who You Are #26: Q.E.D./I.D.
is, in part, autobiographical. Piper, who
has a Ph.D. from Harvard, is a distin-
guished professor of philosophy as well
as a practicing artist. The young woman
in graduation robes and the middle-aged
female teacher pictured in the photograph
at the center demonstrate the successes
achieved by Black women against tough
cultural odds. *Q.E.D./I.D.* reminds us of
the obstacles and battles these women
face as they are constantly required to
define and prove themselves: Q.E.D. is
the abbreviation for the Latin phrase
quod erat demonstrandum, meaning
"which was to be demonstrated."

ROBERT MOSKOWITZ
American, born 1935

Untitled, 1991
Oil on canvas, 108 x 66 inches, gift of David Lurton Massee, Jr., Dr. and Mrs. Stephen Phillips, and Dr. and Mrs. James A. Stewart in honor of Edward G. Weiner, 1992.395

Robert Moskowitz explores the tension between abstraction and representation. Like many of the artists of his generation, Moskowitz was fascinated by popular culture and soon augmented his early, heavily-worked canvases with found objects, such as window shades. He gradually distilled the images in his painting to simple profiles–the World Trade Center, a windmill, an iceberg, even the tail fins of a Cadillac. He placed these diagrams on smooth, monochromatic backgrounds without any visible brushstrokes, creating a very flat pictorial space. Moskowitz painted subjects that particularly fascinated him over and over again, concentrating on subtle nuances of form and tone, and the dynamic, often ambiguous reading of the shape against the background.

In *Untitled*, 1991 (originally titled *Boat and Chain*), a partial glimpse of a curve–perhaps the hull of a ship–is opposed by heavy, regular links of a chain: foreground and background seem to flip in and out of place. The lack of ready connection between these graphic images forces the viewer toward the experience that Moskowitz seeks: "When people look at my work I want them to just discover it in a quiet way–not unlike when you're walking down the street and see something and then realize that it's just there."

EDWARD RUSCHA
American, born 1937

Home Power, 1988
Acrylic on canvas, 60 x 105 inches, purchase
with 20th Century Art Acquisition Fund,
1988.1

Ed Ruscha's poetic visions of the popular
cultural landscape first gained widespread
recognition in the 1960s. In *Home Power*,
an archetypal suburban house–an icon of
shelter, warmth, and safety–glows mys-
teriously from within, possessed by a
strange energy and unseen inhabitants.
The house becomes a symbol of a fortified
homestead in the frontier of suburbia.
Home Power also hints at the anonymity
and the dark facade of pre-fab life in the
1980s; is "home power" the power of the
family, the (perhaps nuclear) power that
lights the house, or both?

Like other pop artists, Ruscha draws
his images from the everyday world and
adopts the techniques and imagery of
commercial culture. *Home Power* and
other paintings of houses executed around
the same time relate to a series of works
by his friend and fellow artist Joe Goode,
based on real estate photographs. Ruscha
has often included strands of text in his
paintings, here implied by the horizontal
white band, which suggests a phrase that
has been censored, as Ruscha invites us to
fill in this blank for ourselves.

KIKI SMITH
American, born Germany, 1954

Mother, 1992-93
Cast glass and steel, shelf: 11 x 18 x 12⁵/₁₆; left foot: 5¹/₂ x 3¹/₂ x 9; right foot: 5¹/₄ x 3³/₄ x 9¹/₄; 56 "tears," dimensions variable, purchase for the Elson Collection of Contemporary Glass, 1993.111

Kiki Smith explores the basic physicality of the human body, in all its frailty and in all its brutality. In 1985, after nearly a decade as a struggling artist, Smith trained to become an emergency medical technician (an occupation with which she briefly supported herself). She finds a primal beauty and poignant expressiveness in what many would term "blood and guts." She regards her sculpture as a means of "describing our relationship of being physical and our relationship with other people's physicality."

Smith often uses materials that evoke a very visceral response–such as wax, mud, and glass. The fragility of glass appeals to Smith, who is often drawn to ephemeral materials.

I like that quality of fragility [in my materials]. I'm making work that's about the body, playing with the indestructibility of life, where life is this ferocious force that keeps propelling us; at the same time, it's also about how you can just pierce it and it dies. I'm always playing between these two extremes about life.

In *Mother*, 1992-93, Smith explores the primal relationship between mother and child. The feet in this work are casts of Smith's mother's feet. The large droplets of glass scattered around them recall tears shed over emotions at the root of mother-daughter relationships–attachment, rebellion, love, separation, and loss.

MARTIN PURYEAR
American, born 1941

Untitled, 1985

Acrylic on pine, Kozo paper on steel mesh,
99 x 60 inches, purchase with funds from
Alfred Austell Thornton in memory of Leila
Austell Thornton and Albert Edward
Thornton, Sr., and Sarah Miller Venable and
William Hoyt Venable, 1994.50

Martin Puryear's wide-ranging knowledge
of non-western art, folk traditions,
methods of joinery, basketry, and other
craft practices pervades his sculptures.
The energy of his slightly asymmetrical,
organic shapes and the evidence of the
artist's hand give his art a special vitality
and a sense of timelessness.

Untitled, 1985, is one of the last of
some forty "rings" Puryear made through-
out the late 1970s and early 1980s. These
roughly circular works are made primarily
of laminated strips of wood. Some are
open, with painted or carved ends; all
have a dynamic feel of torque and of the
quivering curve. Hanging on the wall,
they maintain a ceremonial and symbolic
presence, as if they were enlarged talis-
mans, amulets, or trophies. *Untitled*,
1985, is one of the largest of these works;
its pendulous, basket-like sack is made
of wire mesh covered with Japanese
Kozo paper.

While serving in the Peace Corps in
Sierra Leone from 1964 to 1966, Puryear
visited craftspeople near the remote vil-
lage where he was stationed and learned
native carving and carpentry techniques.
Puryear then studied printmaking at the
Swedish Royal Academy of Art and
learned Scandinavian furniture and wood-
working methods on his own. Such time-
honored craft techniques contribute to the
quietistic quality of his art. "The object
should have a rationale which grows out
of the making and points to the maker. I
want this rationale to be perceivable to the
senses and not [to] be simply cerebral."

SEAN SCULLY
American born in Ireland, 1945

White Robe, 1990
Oil on linen, 96 x 120 inches, purchase with funds from Alfred Austell Thornton in memory of Leila Austell Thornton and Albert Edward Thornton, Sr., and Sarah Miller Venable and William Hoyt Venable, 1992.5

Sean Scully complicates and enlivens the gridded geometric format typical of minimalist art of the 1960s and early 1970s. He paints his canvases freely with a wide house painter's brush, which gives them a powerful sense of touch that contrasts with the mechanical look of much minimalist art. Scully builds up layer upon layer of rich oil paint. Glimpses of ochre and red underpaint bleed through the off-white stripes, creating a complex cumulative color and a visceral sense of the process of the painting's making.

The signature stripes of Scully's paintings are endlessly adaptable, neutral building blocks. He passionately renders them in states of precarious balance–verticals engage horizontals, darks wrestle lights. The seething surfaces of works like *White Robe* are grounded by the forceful geometric composition. "One of my objectives . . . is to make the paintings 'classical' in one way–they do use a stable structure– but schizophrenic in another way–in the violence of the abutments."

Elements of Scully's paintings (like the stripes and inset panels in *White Robe*), allude to urban architecture. The artist's vibrant sense of patterning is also related to a pivotal trip he made in 1969 to Morocco, where the color, decorative tiles, fabrics, rugs, and the brightly-dyed wools made a strong impact on him. He recalled "stripes–all different colors–[laid] to dry side by side, in a very ordered way. In the bright sun . . . it was intoxicating."

SOL LeWITT
American, born 1929

Irregular Bands of Color, 1993

Ink washes, six parts, five 180 x 180 inches, one 358¼ x 180 inches, overall 718¼ x 360 inches, gift of Mark and Judith Taylor through the 20th Century Art Acquisition Fund and the 20th Century Art Society, 1993.1

Sol LeWitt created *Irregular Bands of Color* on the occasion of the tenth anniversary of the High Museum of Art's acclaimed building by Richard Meier. LeWitt's design is a star that explodes across six of the floating panels in the atrium; it is rendered in a spectrum of lively colors, selected with the bright light of the space in mind. LeWitt's dynamic image mirrors the vibrancy of the atrium–the Museum's most active and public gathering space.

Like many of his peers in the late 1960s, LeWitt strove to make art that was objective and straightforward. He frequently worked in series, used modular geometric units, and preferred industrial materials such as plastic or steel. LeWitt's first wall drawings (begun in 1968) were simple linear patterns drawn in pencil or colored chalk directly onto white walls. Over the years, his drawings have grown larger, more colorful, and increasingly complex. Over seven hundred of LeWitt's wall drawings have been executed in museums, galleries, and private collections around the world.

For LeWitt, the *concept*, rather than the execution, of a work is most important: "The idea is the machine that makes the art," he says. LeWitt's approach to making art is similar to that of a composer who writes music for others to perform. He conceives of a work and communicates the process and image through verbal description, which is then translated into sketches and plans. A team of trained assistants executes LeWitt's wall drawings on site.

Here, LeWitt's assistants applied water-based inks to specially prepared walls. They used cloths to rub on the inks in successive layers (at least three for each color); as a result, the colors have great luminosity and rich subtleties. For each application, the design was carefully masked in order to maintain crisp edges. The clean lines of the finished composition are balanced against the variations and "hand-worked" look within each band.

PHOTOGRAPHY

GEORGE N. BARNARD
American, 1819-1902

City of Atlanta, No. 2, 1866
From the album "Photographic Views of Sherman's Campaign," albumen print, 10 x 14 inches, purchase, 1985.226.46

George N. Barnard served as the official photographer of the Army of the Cumberland's Department of Engineers. After Atlanta fell to Sherman's forces in September 1864, Barnard accompanied the army on its march to Savannah, recording topographic views, railroad lines, roads, and defensive works as supplements to official reports.

Barnard capitalized on his wartime experiences by publishing a deluxe photographic album accompanied by a small volume of historical texts and several official campaign maps. The limited edition sold by subscription for the high price of one hundred dollars. The sixty-one plates were roughly arranged according to the geographic sites that had figured prominently in the Union Army's maneuvers.

Many of Barnard's photographs, like this view of Atlanta, were made on an 1866 return trip which retraced the route the Union Army had taken from Nashville to Charleston. This work shows the center of Atlanta at what is now the intersection of Peachtree and Wall Streets near Underground Atlanta. In the right foreground, the Georgia Railroad Bank stands in ruins, a poignant image of civic order overwhelmed by human conflict.

WILLIAM HENRY JACKSON
American, 1843-1942

Cañon of the Rio Las Animas,
ca. 1882
Albumen print, 27³/₄ x 21³/₄ inches, gift of
Life Insurance Company of Georgia, 1980.117

After nearly a decade as a member of F. V.
Hayden's U.S. Geological and Geographic
Survey of the Territories, William Henry
Jackson established his own commercial
studio in Denver in 1879 and received the
first of many commissions from Western
railroad companies to record the natural
wonders along various routes through the
Rocky Mountains. Some of Jackson's most
striking images, including this one, were
produced for the Denver & Rio Grande
Railway, "the scenic line of America" and
the longest in the world. Jackson made
several different mammoth plates of the
Canyon of the River of Lost Souls in the
late summer of 1882. In all of the prints,
there can be found something of what the
historian Leo Marx called "the technologi-
cal sublime," the skillful accommodation
of the sweeping forces of nature to the
determinism of modern progress.

From an angled position below, Jackson
directs our attention up a precipitous
incline towards the train perched trium-
phantly on the rockface; beyond is a
glimpse of the rail span itself. The place-
ment of the human figure acknowledges
the smallness of man, whether measured
against his own efforts or the vast terrain
that surrounds him. The man turns to
face us, a surrogate for the tourist and
armchair traveler to whom this image was
marketed, and a witness to the camera's
ability to present a faithful transcription
of all that it surveyed.

THOMAS EAKINS
American, 1844-1916

*Eight Exposures of a Male Nude
Model*, ca. 1880-83
Albumen prints, 3¹/₄ x 9⁷/₁₆ inches, gift of
Jack Titleman, 1986.205

In order to analyze anatomy, perspective, and motion for greater accuracy in his paintings, Thomas Eakins took up photography around 1880. He used his photographs not only as personal notes and references, but as an aid in his classes at the Pennsylvania Academy of the Fine Arts in Philadelphia, once his practice of teaching from nude models had become controversial. It is likely that Eakins used these sequenced images to demonstrate to his students what he called "the center line," or the central axis of the figure, depending upon the body, weight, posture, and pose of the model.

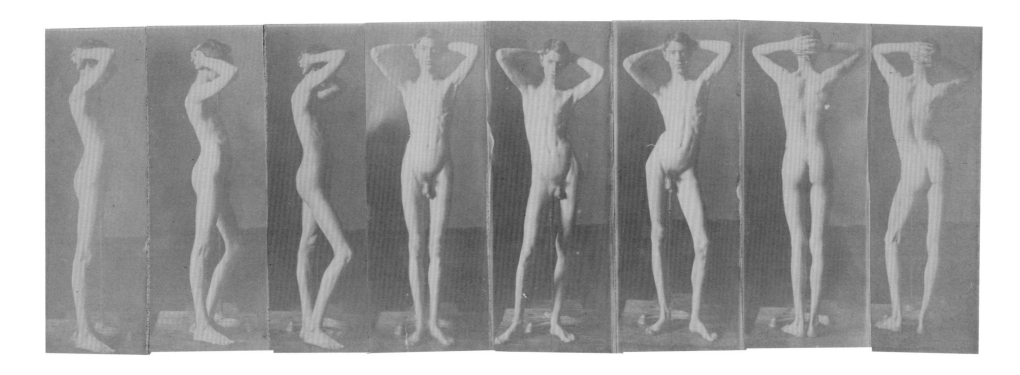

Heinrich Kühn
Austrian, born in Germany, 1866-1944

On the Hillside (A Study in Values), before 1910
Bromoil transfer print, 9½ x 11⅞ inches, purchase with funds from Georgia-Pacific Corporation, 1987.137

Henrich Kühn was a leading Austrian photographer who, like Alfred Stieglitz in America and Robert Demachy in France, was instrumental in establishing photography as a fine art at the turn of the century. *On the Hillside (A Study in Values)*, a picture of the artist's daughter Lotte glimpsed in a moment of quiet absorption, is typical of Kühn's best images, which reveal a nuanced and captivatingly fresh appreciation of the special qualities of domestic life.

To achieve the soft luminosity and indeterminacy of time and place which characterize this work, Kühn turned away from the straight photograph, with its insistent clarity, exactitude, and recessional perspective. He became, as Stieglitz noted, "an indefatigable experimenter" with processes such as gum bichromate, platinum, hand-painted photogravure, and bromoil (in this instance), as well as with other more hybrid combinations. These techniques allowed Kühn to rework the surface of images by hand and to alter the size, tonal range, and color of the finished print. Although Kühn may appear very much a traditionalist in his approximation of the graphic arts, his work was perceived by the artists of his own generation as a radical break from the narrow rules then governing photographic practice.

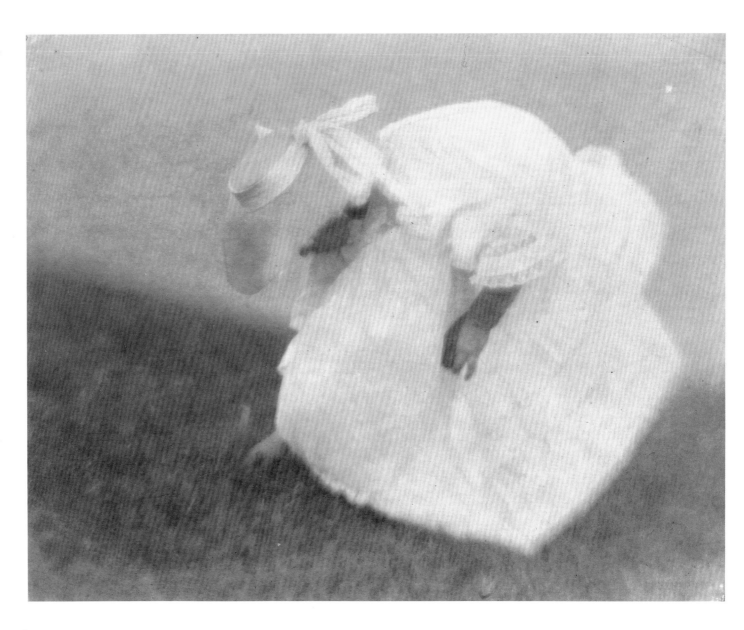

Interestingly, Kühn's revival of interest in non-silver processes anticipates the concerns of many artists working in the 1950s and 1960s, who similarly adopted alternative photographic methods and explored the incorporation of other mediums and sensibilities into their picture-making.

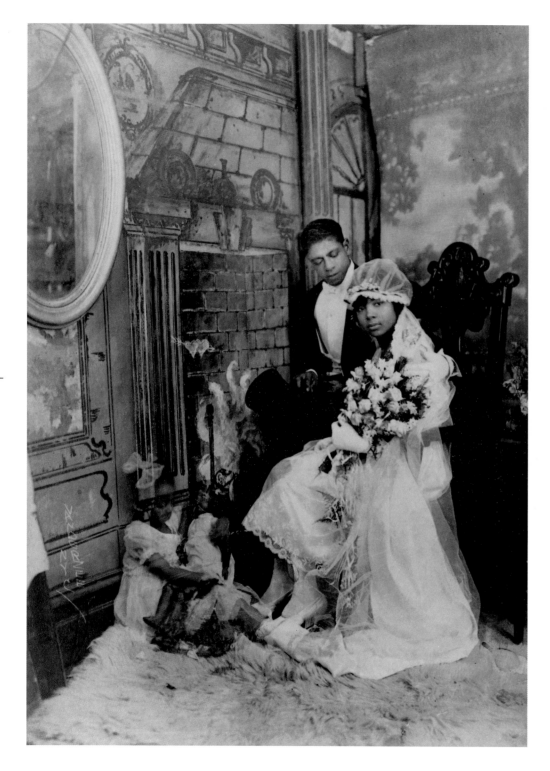

JAMES VANDERZEE
American, 1886-1983

Future Expectations (Wedding Day), 1926, printed 1974
Gelatin silver print, 9½ x 6⅞ inches, purchase, 74.143 1

James VanDerZee was the most important photographer of the Harlem Renaissance, a period roughly from 1919 to 1929 during which Harlem was the undisputed capital of African-American culture and the focus of intense artistic, literary, and musical activity. VanDerZee's unmatched recording of the Harlem experience included portraits of middle-class families, religious and political leaders, artists, and entertainers, as well as photographs of organizations and events.

VanDerZee continued the nineteenth-century practice of using painted backdrops in his studio portraits, and he did not hesitate to manipulate his images, both before the camera and by retouching them in the darkroom. While retouching was often shunned by the artistic community, VanDerZee's clients liked the effect when he removed their unwanted lines and blemishes and sometimes even replaced their hair by scratching on the surface of the negative. He also frequently employed the technique of combination printing, the use of more than one negative to make a single photograph, which he found to be a particularly effective way to tell a story. In this characteristic photograph, he combined a wedding portrait with a vision of the daughter he predicted for the couple's future.

ALEXANDER RODCHENKO
Russian, 1891-1956

Lathe Machine Tools, 1929

Gelatin silver print, 9⁷/₁₆ x 6³/₄ inches, gift of
the Rodchenko-Stepanova Archive, Moscow,
1994.37

After the Bolshevik Revolution in 1917, the poet and playwright Vladimir Mayakovsky exhorted his fellow artists to construct a new definition of Russian culture: "In the name of the great march of equality for all, as far as culture is concerned, let the free work of creative personality be written on the corners of walls, fences, roofs, the streets of our cities and villages, on the backs of automobiles, carriages, street-cars, and on the clothes of all citizens. . . ."

Mayakovsky's call for an art which could serve the goals of social reconstruction was heeded by many like-minded individuals, among them his close friend and collaborator Alexander Rodchenko. In the early 1920s Rodchenko renounced his radical experimentation with non-objective painting and sculptural construction to focus on "utilitarian" or applied arts that could, as he put it, "flow into the organization of life." He worked prolifically in the fields of commercial and industrial design, publishing, architecture, theater, and film, but from 1924 onwards, the camera would become his primary vehicle of expression. In photography, as in his other creative endeavors, Rodchenko fashioned a new visual language that was unorthodox, immediately influential and, ultimately, politically controversial.

This photograph was part of a pictorial essay on the Hammer and Sickle factory originally published in the widely circulated magazine *Daësh (We Produce)* in 1929. The knife-like diagonal thrust of the picture plane, the unusual perspective, abrupt cropping, and rhythmic patterning of light and shade seen here were among the strategies Rodchenko frequently invoked, and in this work, they aptly express the monolithic power, transformative energy, and ambiguously complex interrelationships resulting from industrialization on a mass scale.

Although Rodchenko's work was enormously influential in Soviet artistic circles and abroad, it was intensely criticized as having become mired in an elitist, western formalism that could not be easily understood by the general populace, thus compromising its persuasive value. A year after this photograph was made, Rodchenko was dismissed from his teaching position, and in 1933 he was jettisoned from the photo-section of *October*, the leftist arts union, shortly before a government decree abolished all arts organizations and declared Socialist Realism the official Soviet aesthetic doctrine.

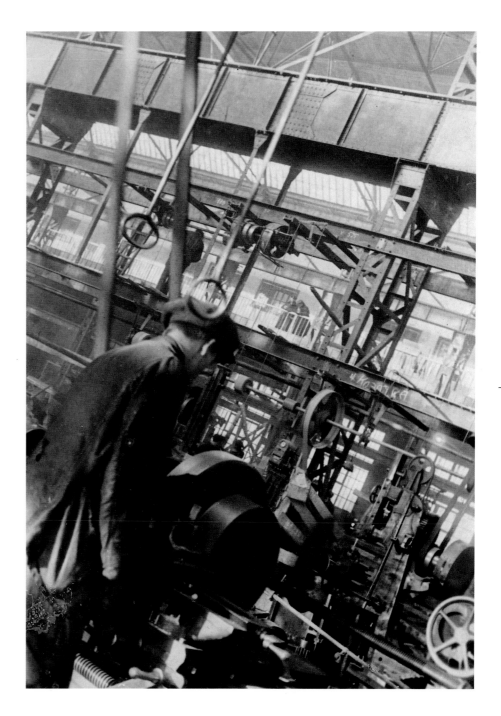

FRANCIS BRUGUIÈRE
American, 1879-1945

The Light that Never Was, on Sea or Land, ca. 1925
Gelatin silver print, 9⅛ x 7 inches, purchase with funds from Georgia-Pacific Corporation, 1986.122

In the 1920s and early 1930s, Francis Bruguière experimented with what he called "designs in abstract forms of light." He often began, as in this photograph, by making an abstract construction from cut paper. Then, with the camera lens open, he moved light over the surface in order to create patterns of shimmering opalescence and fluidity. In work completely devoid of subject matter, Bruguière sought a way of "apprehending light as an active symbol of consciousness." The title of this work is taken from William Wordsworth's *Elegiac Stanzas Suggested by a Picture of Peele Castle, in a Storm, Painted by Sir George Beaumont* (1805), in which the poet contemplates the transformative powers of the imagination:

> Ah! then, if mine had been the
> Painter's hand,
> To express what then I saw; and add
> the gleam,
> The light that never was, on sea or
> land,
> The consecration, and the Poet's
> dream.

EDWARD WESTON
American, 1886-1958

Palma Cuernavaca II, 1925
Platinum print, 9¼ x 6¼ inches, gift of
Lucinda W. Bunnen for the Bunnen Collec-
tion to mark the retirement of Gudmund
Vigtel, 1991.54

Edward Weston began work on this
photograph on November 25, 1925, in
the Cuernavaca garden of Frederick Davis,
an art collector and owner of the Sonora
News Company. The tree in Davis's
garden was also the model for an earlier
study of a palm trunk which Weston
remembered as "topped by a circle of dark
but sungleaming leaves." This version par-
ticularly recalls Weston's 1922 images of
smoke stacks taken at the American
Rolling Mills Company in Middletown,
Ohio, not only in its basic cylindrical
shape, but also in the stripping away of
extraneous detail to reveal an inherent
purity of form–what Weston described as
the "very substance and quintessence of
the thing itself."

In his *Daybooks*, Weston wrote about
the recurring fascination this subject held
for him: "Why should a few yards of a
white tree trunk, exactly centered, cutting
across an empty sky, cause such real
response? And why did I spend my hours
doing it? One question simply answered–
I had to!"

103

HARRY CALLAHAN
American, born 1912

Weeds in Snow, Detroit, 1943
Gelatin silver print, 8 x 10 inches, gift of
Arnall Golden and Gregory through the
20th Century Art Acquisition Fund, 1985.32

Honored today as one of photography's
most influential artists and teachers,
Harry Callahan studied engineering at
Michigan State University from 1931 to
1933. In 1938, he bought his first camera
and became active in local amateur circles
while employed as an accounting clerk at
the Chrysler Motor Parts Corporation in
Detroit. In 1941, Callahan enrolled in two
weekends of workshops conducted by
Ansel Adams, who had come to the city at
the invitation of Arthur Siegel, a pho-
tographer who had studied with László
Moholy-Nagy at the New Bauhaus in
Chicago. This encounter with Adams
proved to be a pivotal experience for
Callahan, and under his influence, he
purchased an 8 x 10 inch view camera
and began to explore the optical sharpness
and tonal integrity associated with the
larger negative.

Though the meeting with Adams was
significant, a year later Callahan began
a series of winter landscapes that con-
sciously rejected one aspect of his techni-
cal orientation—fidelity to the full range of
textural and tonal values found in nature.
In *Weeds in Snow, Detroit*, Callahan's
incipient interest in abstraction is evident,
as is the deceptively understated yet rig-
orous formalism and intuitive preceptive-
ness that would characterize much of his
later work.

WALKER EVANS
American, 1903-1975

Untitled, from "New York
Subway Portraits," 1938-41
Gelatin silver print, 7½ x 4¾ inches,
purchase, 75.46

After meeting Berenice Abbott and seeing
her large collection of work by Eugène
Atget, Evans revolted against the
"accepted ideas of beauty" and the mod-
ernist strategies he had adopted in many
of his New York scenes. He was drawn
instead "toward the enchantment, the
visual power, of the aesthetically rejected
subject," and his work became charac-
terized by a new economy and emotional
reserve that can be seen in this portrait of
two subway riders from a series taken
between 1938 and 1941.

 When these portraits were first pub-
lished in *Harper's Bazaar* in 1962, Evans
described himself as "a penitent spy and
apologetic voyeur," referring in part to
the covert nature of this specific body of
work, which was achieved through the
use of a small camera concealed in his
coat with the shutter release connected
to a wire which ran down his sleeve. In
Evans's hands, surveillance yields an
incisive portrayal of two people, physi-
cally near but socially isolated from one
another, as they shuttle through the sub-
terranean recesses of the city.

CLARENCE JOHN LAUGHLIN
American, 1905-1985

The Waters of Memory, 1946
Gelatin silver print, 10³/₄ x 13¹/₂ inches, gift of
the Laughlin Estate, 1985.106

The remarkable photographs of Clarence
John Laughlin, who lived and worked
mostly in New Orleans, anticipate the
concerns of many artists working over the
past two decades. Beginning in the 1930s,
Laughlin obsessively explored the
interplay between text and images, the
tension between the psychological and the
didactic, and the blurring of distinctions
between objective and subjective modes
of seeing. Many of Laughlin's architectural
studies, still lifes, and portraits were cre-
ated in a straightforward manner; others
were staged with props and models, incor-
porated collaged materials or multiple
exposures, and included other interven-
tions between reality and the scene
finally recorded.

Laughlin's work was unified by his
need to convert the merely factual into
the deeper imaginative and metaphysical
dimensions of experience. In the interpre-
tive caption assigned to *The Waters of
Memory*, one of his many symbolic
images of antebellum plantations,
Laughlin writes about this idea:

> Through the magic of the camera
> allied with the human imagination, we
> plunge into what seems the lustrous
> waters of memory; we plunge, as
> through great dark veils of time, into a
> world that many of us seek, sporadi-
> cally to rediscover–the world of our
> childhood, the house of our dreams,
> the world of all lost years.

WILLIAM CHRISTENBERRY
American, born 1936

Side of Palmist Building, Havana Junction, 1971
Chromogenic color print, 3½ x 5¼ inches, purchase, 1977.87

William Christenberry grew up near Hale County, Alabama, where Walker Evans had photographed impoverished share-croppers in 1936. Evans's images were pub-lished with text by James Agee in 1941 in the influential book *Let Us Now Praise Famous Men*, and Christenberry's discov-ery of the book in 1961 had a profound effect on his art. Christenberry began re-photographing the sites that Evans had visited, showing the effects of twenty-five years on buildings already dilapidated in 1936.

Christenberry was particularly drawn to the Palmist Building, which had been a general store run by his uncle when he was a child. It had since been inhabited and then abandoned by a band of gypsies, whose advertising sign for palm reading had been stuck upside down into a broken window to keep out the rain. On his yearly visits home to Alabama, Christenberry photographed the Palmist Building and its sign, poignantly docu-menting their deterioration. He explained:

> I am genuinely fascinated with the passage of time. I am fascinated by how things change, how one of these signs, for example—it was once in mint condition, an object put there to sell, advertise a product—takes on a wonder-ful character, an aesthetic quality through the effect of the elements and the passage of time.

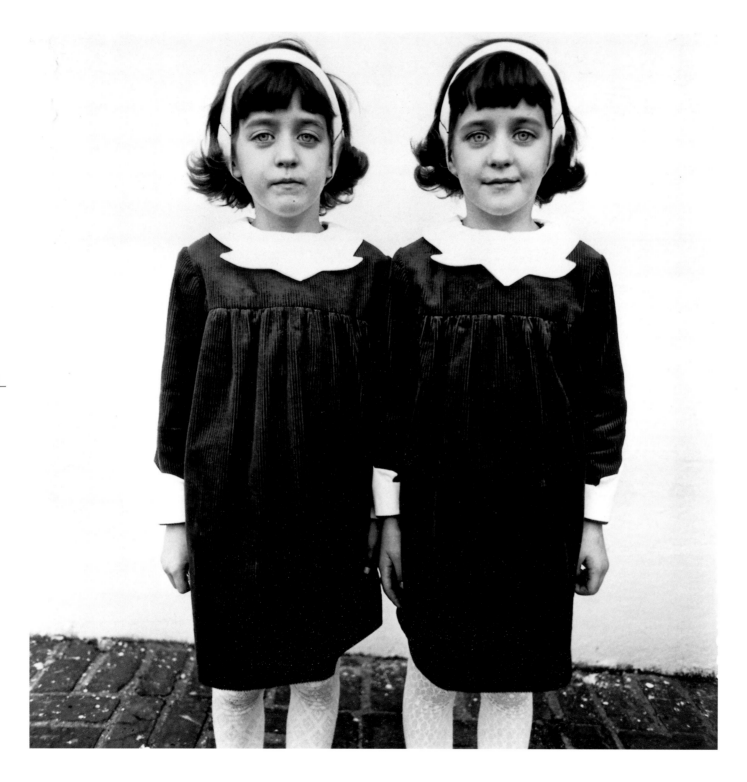

DIANE ARBUS
American, 1923-1971

Identical Twins, Roselle, N.J.,
1966, printed by Neil Selkirk,
1973
Gelatin silver print, 15 x 14³/₄ inches,
purchase, 74.81 g

Diane Arbus became a fashion photographer at eighteen and, with her husband Allan Arbus, enjoyed a successful career working for most of America's major fashion magazines. In 1959, she abandoned fashion to study with photographer Lisette Model. Arbus often turned her camera on those who deviated from the norm–nudists, transsexuals, the physically and mentally handicapped–not to ridicule them but to invest them with a sense of humanity. Arbus's privileged upbringing in a wealthy family, where she was insulated from pain and ugliness, perhaps led her to seek such extremes:

> One of things I felt I suffered from as a kid was I never felt adversity. I was confirmed in a sense of unreality which I could only feel as unreality. . . . The world seemed to me to belong to the world. I could learn things but they never seemed to be my own experience.

Arbus always photographed head on, confronting her subject. Less interested in composition or visual inventiveness than in revealing the psychological truths of those she photographed, Arbus often presented her middle-class subjects more harshly than those further from the mainstream. This photograph of twins–identical but profoundly different–seems to suggest that behind their sameness (and the conformity of middle-class society) lie discomfort and turmoil.

CINDY SHERMAN
American, born 1954

Untitled Film Still, 1979
Gelatin silver print, 29½ x 39½ inches, purchase with funds from Lucinda W. Bunnen for the Bunnen Collection, 1981.160

In an early body of work, *Untitled Film Stills* (1977-80), Cindy Sherman staged photographs suggested by the glossy prints used to publicize the low-budget movies of the 1950s and 1960s. Although she cast herself as the protagonist in these photographs, they are not self-portraits. Rather, through her selection of costume, pose, and prop, Sherman transformed herself into the wide-eyed ingenue, the voluptuous starlet, the harried housewife, and other readily identifiable types.

Feminist scholars have been particularly drawn to Sherman's work and its examination of the way art, film, and popular culture often depict women as stereotypes. Furthermore, because she uses herself as a model, some have seen Sherman as taking control of her own image in reaction against the way female images have traditionally been determined by men. Other observers have suggested that Sherman questions the authenticity of *any* identity in an age in which self and society are so thoroughly encoded and visualized by mass media imagery.

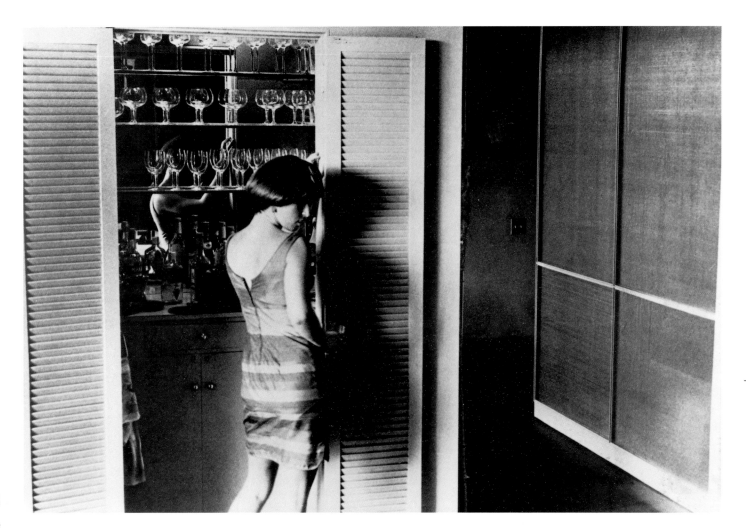

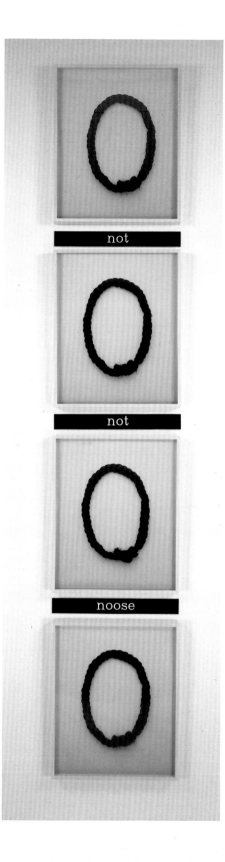

LORNA SIMPSON
American, born 1960

Double Negative, 1990
Dye diffusion transfer prints and plastic,
each print 23⅞ x 19⅝ inches, purchase with
funds from the National Endowment for the
Arts and Edith G. and Philip A. Rhodes,
1990.69.

Lorna Simpson's enigmatic combinations
of photos and text relate to signifying, an
African-American language practice in
which participants arrive at the meaning
of a word or phrase through conjecture.
An object of the game is to trump one's
opponent by turning a phrase around to
mean something entirely different. Also
known as "slave's-trope," signifying is
often used to undermine pretension.

The braided rings of hair in *Double
Negative* allude to racial identity and
childhood, but the suggestion of inno-
cence is undermined by the resemblance
of the repeated loop to a noose–a potent
reference to lynchings and racial hatred.
Simpson puns "not" and "knot"; her title
refers to the grammatical double negative
presented in the text, to black dialect, and
also to the cultural double negative (and
double bind) of being black *and* female.

James Casebere
American, born 1953

Georgian Jail Cages, 1993
Dye destruction print, 37½ x 29½ inches,
purchase with funds from the Massey
Charitable Trust for the Bunnen Collection,
1994.18

James Casebere constructs his subjects
expressly for the camera, building meticu-
lous small-scale models out of such fea-
tureless materials as foam core, museum
board, plaster and (for the ground) felt, and
white paint. With a view camera, he then
photographs the model, bathed in an aus-
tere, theatrical lighting, from a formal,
almost pedestrian vantage point. The
initial model is scaled in miniature, but
the final photographic print (or back-lit
transparency) is most often an enlarge-
ment measuring an average of 30 to 40
inches high or wide.

Casebere's "Prison" series depicts both
the interior cells and exterior facades of
various prison types throughout history,
such as the portable cages used to trans-
port and house crews of convicts sent to
work camps in Georgia well into the
1960s. The imagery here avoids the harsh
realism and overt didacticism of much
documentary work on the same subject
produced in the 1930s. It moves beyond
social commentary, and instead the prison
becomes a metaphor for the profound
anxieties of the individual, whether incar-
cerated or free, in relation to contempo-
rary society.

Photo Credits